Chaos, Territory, Art

Wellek Library Lectures in Critical Theory

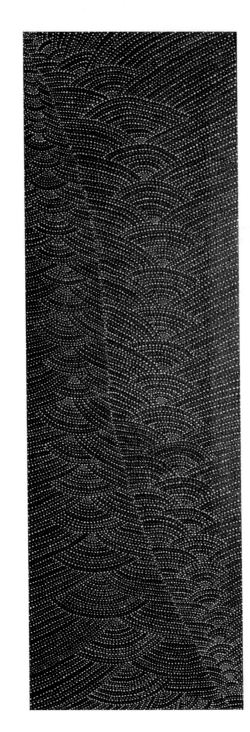

CHAOS, TERRITORY, ART

Deleuze and the Framing of the Earth

Elizabeth Grosz

COLUMBIA UNIVERSITY PRESS
NEW YORK

Frontispiece: *Mountain Devil Lizard* copyright © Nancy Kunoth Petyarre.
Courtesy Walkabout Gallery, Sydney, Australia.

Columbia University Press
Publishers Since 1893
New York Chichester, West Sussex
Copyright © 2008 Columbia University Press
Paperback edition, 2020
All rights reserved
Library of Congress Cataloging-in-Publication Data
Grosz, E. A. (Elizabeth A.)
 Chaos, territory, art : Deleuze and the framing of the earth / Elizabeth Gro-
sz.
 p. cm. — (The Wellek library lectures)
 Includes bibliographical references and index.
 ISBN 978-0-231-14518-3 (cloth : alk. paper)—ISBN 978-0-231-14519-0
(pbk. : alk. paper)—ISBN 978-0-231-51787-4 (e-book)
 1. Deleuze, Gilles, 1925–1995. 2. Arts—Philosophy. I. Title.

B2430.D454G76 2008
700.1—DC22

 2007047572
 ∞
Casebound editions of Columbia University Press books are
printed on permanent and durable acid-free paper.
Printed in the United States of America

Cover image: Kathleen Petyarre, *Mountain Devil Lizard Dreaming
(with Winter Sandstorm)*. Aileen Thompson Bequest Fund through the Art
Gallery of South Australia Foundation, 1996, Art Gallery of South Australia,
Adelaide. © estate of the artist licensed by Aboriginal Artists Agency Ltd.
Cover design: Milenda Nan Ok Lee

The Wellek Library Lectures in Critical Theory are given annually at the University of California, Irvine, under the auspices of the Critical Theory Institute. The following lectures were given in May 2007.

<div align="right">
The Critical Theory Institute

John Smith, director
</div>

CONTENTS

Acknowledgments ix

ONE
Chaos. Cosmos, Territory, Architecture 1

TWO
Vibration. Animal, Sex, Music 25

THREE
Sensation. The Earth, a People, Art 63

Bibliography 105
Index 111

ACKNOWLEDGMENTS

My strong and heartfelt thanks must go to the Critical Theory Institute at the University of California, Irvine, for inviting me to present the Wellek Library Lectures in May 2007, and particularly to John Smith, director and Lisa Ness, administrative coordinator, who made my time at Irvine remarkably smooth and stimulating. Thanks must also go to Jennifer Crewe of Columbia University Press who enabled the transition from spoken to written text to be as seamless, direct, and rapid as I could have hoped.

I owe an immense and unrepayable intellectual debt, in all my work and especially here, to Luce Irigaray who developed what I believe is the most alluring and productive concept of contemporary thought, the concept of the irreducibility of sexual difference. Without her rigorous and unflinching understanding of sexual difference as the very engine of life on earth, feminist theory would be tied to the sociological concept of gender and the horizon of egalitarianism instead of opened up to major ontological questions about matter, force, nature, and the real and to the vast explorations of a politics of difference.

Gilles Deleuze, in his own writings as well as in his collaborations with Félix Guattari, is the second major intellectual resource I have relied on here and everywhere in my work. Without his, and their, major concepts—chaos, the planes of immanence and composition, territorialization, deterritorialization, and many others—I would have had nothing to say about art, at least nothing philosophical. Taken together, Irigaray and Deleuze, alone and in his collaborations with Guattari, generate a tension, their concepts do not fit together well, they produce an uneasiness that I have found exhilarating, problematic, and inspiring. Taken together— and mediated through the writings of Darwin—they enable us to understand the productive and artistic interactions between living sexed bodies, and a dynamic, unpredictable and eventful world.

Many others, more personally accessible to me than Irigaray or Deleuze, have enabled me to prepare and complete this current project (in no particular order): Margherita Long, Jill Robbins, Joanna Regulska, Harriet Davidson, Joanne Givand, Pheng Cheah, Sue Best, Philipa Rothfield, Ellen Mortensen, Jami Weinstein, John Rajchman, and Anna Rubbo. I owe a particular debt to Claire Colebrook, who carefully read the manuscript and made incisive and helpful suggestions for change.

My various places of employment—the Women's and Gender Studies Department at Rutgers, the School of Architecture, Design and Planning at the University of Sydney, and the Centre for Women's and Gender Studies at the University of Bergen, Norway— instead of delaying my writing, have helped to inspire and sustain it! I am very grateful for their support and for the dynamic and provocative students I have taught in each institution who have challenged me to become as sharp and clear as I can. My thanks to all. I owe a special debt of gratitude to my family—to Eva Gross, Tom Gross, Irit Rosen, Tahli Fisher, Daniel Gross, and Mia Gross—who have always supported and encouraged me. My particular thanks to Nicole Fermon whose wit, wisdom, and inspiration lay behind this interest in the arts and my interest in their implications for reconsidering the status of philosophy.

A version of chapter 1, then titled "Chaos, Territory, Art," was published in *IDEA (Interior Design/ Interior Architecture Educa-*

tor's Association; 2005), 15–29; a version of chapter 2, "Vibration. Animal-Music-Sex" was published online for the New Constellations. Science, Art and Society Conference presented at the Museum of Contemporary Art in Sydney, March 2006.

My thanks to the Art Gallery of South Australia and Gallerie Australis for permission to publish Kathleen Petyarre's *Mountain Devil Lizard Dreaming (with Winter Sandstorm)* on the front jacket cover and to Walkabout Gallery for Nancy Kunoth Petyarre's *Mountain Devil Lizard* copyright © Nancy Petyarre.

Chaos, Territory, Art

I

CHAOS. COSMOS, TERRITORY, ARCHITECTURE

Art and nothing but art! It is the great means of making life possible, the great seduction of life, the great stimulant to life. Art [i]s the only superior counterpart to a will to denial of life.

—FRIEDRICH NIETZSCHE,
THE WILL TO POWER

This small book is directed to questions about the ontology, that is, the material and conceptual structures, of art. While I am not trained in the visual or spatial arts, there are, nonetheless, many points of overlap, regions of co-occupation, that concern art and philosophy, and it is these shared concerns that I want to explore here. I want to discuss the "origins" of architecture, music, painting—indeed, the arts in general—but not the historical, evolutionary, or material origins of art, confirmable by some kind of material evidence or empirical research such as would interest an archaeologist, anthropologist, or historian. Rather, I aim to explore the conditions of art's emergence, what makes art possible, what *concepts* art entails, assumes, and elaborates. These, of course, are linked to evolutionary and material forces, that is to say, to the historical elaboration of life, but are nevertheless metaphysically or ontologically separable from them.

Art, according to Gilles Deleuze, does not produce concepts, though it does address problems and provocations. It produces sensations, affects, intensities as its mode of addressing problems, which sometimes align with and link to concepts, the object of philosophi-

cal production, which are how philosophy deals with or addresses problems. Thus philosophy may have a place not so much in assessing art (as aesthetics has attempted to do) but in addressing the same provocations or incitements to creation as art faces—through different means and with different effects and consequences. Philosophy may find itself the twin or sibling of art and its various practices, neither judge of nor spokesperson for art, but its equally wayward sibling, working alongside art without illuminating it or speaking for it, being provoked by art and sharing the same enticements for the emergence of innovation and invention. My goal is to develop a nonaesthetic philosophy for art, a philosophy appropriate to the arts that neither replaces art history and criticism nor claims to provide an assessment of the value, quality, or meaning of art, but instead addresses the common forces and powers of art, the regions of overlap between the various arts and philosophy.

My guides in the following explorations will be the writings of Deleuze and Deleuze and Guattari together and their critiques of signification and subjectification, the two dominant paradigms that have directed both feminist and postmodern politics; and the writings of Irigaray, with her insistence on the sexual specificity and irreducible bodily difference as the very motor of cultural and philosophical production. Through Deleuze, Guattari, and Irigaray, and their opening up of both nature and culture to unrecognized and open-ended forces, my goals will be to develop new ways of addressing and thinking about the arts and the forces they enact and transform and thus, indirectly, new ways of conceptualizing politics and the ways in which art and politics can be linked together and rethought.

In my previous work I focused on the ways in which bodies, and the forces of space, time, and materiality, that is, nature, have enabled rather than inhibited cultural and political production.[1] In this chapter, through Deleuze, Guattari, and Irigaray, I would like to address how these forces cohere to enable the productive explosion of the arts from the provocations posed by the forces of

1. See, in particular, Grosz 2004 and 2005.

the earth (cosmological forces that we can understand as chaos, material and organic indeterminacy) with the forces of living bodies, by no means exclusively human, which exert their energy or force through the production of the new and create, through their efforts, networks, fields, territories that temporarily and provisionally slow down chaos enough to extract from it something not so much useful as intensifying, a performance, a refrain, an organization of color or movement that eventually, transformed, enables and induces art.

Deleuze suggests, in opposition to those philosophical or phenomenological approaches to the arts that analyze their intentionality or the mutual engagements of subjects and objects in artworks, that the arts produce and generate intensity, that which directly impacts the nervous system and intensifies sensation. Art is the art of affect more than representation, a system of dynamized and impacting forces rather than a system of unique images that function under the regime of signs.[2] By arts, I am concerned here with all forms of creativity or production that generate intensity, sensation, or affect: music, painting, sculpture, literature, architecture, design, landscape, dance, performance, and so on. I am not interested in providing qualitative evaluations of works of art, in distinguishing "good" from "bad" or high from low art, in setting up some sort of hierarchy of the various arts, but in exploring the peculiar relations that art establishes between the living body, the forces of the universe and the creation of the future, the most abstract of questions, which, if they are abstract enough, may provide us with a new way of understanding the concrete and the lived.

2. Sensations, affects, and intensities, while not readily identifiable, are clearly closely connected with forces, and particularly bodily forces, and their qualitative transformations. What differentiates them from experience, or from any phenomenological framework, is the fact that they link the lived or phenomenological body with cosmological forces, forces of the outside, that the body itself can never experience directly. Affects and intensities attest to the body's immersion and participation in nature, chaos, materiality: "*Affects are precisely these nonhuman becomings of man, just as percepts—including the town—are nonhuman landscapes of nature*" (Deleuze and Guattari 1994:169).

What distinguishes the arts from other forms of cultural pro-
duction are the ways in which artistic production merges with,
intensifies and eternalizes or monumentalizes, sensation. Material
production—the production of commodities—while it may gen-
erate sensation, is nevertheless directed to the accomplishment of
activities, tasks, goals, or ends. The production of commodities,
even "artistic commodities," directs itself to the generation of pre-
experienced sensations, sensations known in advance, guaranteed
to affect in particular sad or joyful ways. This is why it is not
clear whether Deleuze understands pop music or mass-produced
art, kitsch, as artistic, though he certainly understands its intensi-
fying effects.[3] Art enables matter to become expressive, to not just
satisfy but also to intensify—to resonate and become more than
itself. This is not to say that art is without concepts; simply that
concepts are by-products or effects rather than the very material of
art. Art is the regulation and organization of its materials—paint,
canvas, concrete, steel, marble, words, sounds, bodily movements,
indeed *any* materials—according to self-imposed constraints, the
creation of forms through which these materials come to generate
and intensify sensation and thus directly impact living bodies, or-
gans, nervous systems.

What can philosophy contribute to an understanding of art
other than an aesthetics, that is, a theory *of* art, a reflection *on*
art? Instead of supervening from above, taking art as its object,
how can philosophy work *with* art or perhaps as and alongside
art, a point of relay or connection with art? Only by seeking what
it shares with art, what common origin they share in the forces of
the earth and of the living body, what ways they divide and orga-
nize chaos to create a plane of coherence, a field of consistency, a

3. See Buchanan and Swiboda (2004), and especially Ian Buchanan's "Deleuze
and Pop Music"; Deleuze himself clearly has a preference for works that might be
considered high modernist, but it is not at all clear that his understanding of art as
the monumentalization of sensation is not a more general characterization of all of
the arts, including both the most everyday and popular, the most ready-made or
found objects, the most quotidian of performances.

plane of composition on which to think and to create.[4] In other words, what common debt do art and philosophy share to those forces, chaos, that each in their own ways must slow down, decompose, harness, and develop (through the construction of the plane of immanence in philosophy and the constitution of the plane of composition in the arts)? How, in other words, do the arts and philosophy ("theory") create? With what resources? Techniques? Counterforces? And what is it that they create when they create "works," philosophical works and artistic works?[5]

I want to start with some mythical sense of "the beginning." "In the beginning" is chaos, the whirling, unpredictable movement of forces, vibratory oscillations that constitute the universe. Chaos here may be understood not as absolute disorder but rather as a plethora of orders, forms, wills—forces that cannot be distinguished or differentiated from each other, both matter and its conditions for being otherwise, both the actual and the virtual indistinguishably. Somewhere in this chaotic universe, in a relatively rare occurrence, through chance, molecular randomness generates

4. If philosophy cannot be understood as the master discipline by which the arts can be comprehended, it is equally true that art cannot be understood as the culmination or fruition of philosophy, as one recent text has claimed: "In his own late works Deleuze addresses these questions of subjectivity, freedom and creation and he does so largely within the domain of *aesthetics*. Deleuze thus makes aesthetics into a sort of master discipline of philosophy, replacing the ontology of sense and repetition from the early work" (Due 2007:164). This is both to mistake Deleuze's understanding of art for an aesthetics and to misunderstand the relations between philosophy and art as a relation of hierarchy or "mastery."

5. Peter Hallward argues a position that is the converse of Due's: that Deleuze positions philosophy as the more spiritualized, less materialized counterpart of art, a step beyond and above art in what he perceives as Deleuze's movement beyond materiality: "If, then, philosophy has any privilege over art it is simply that it is able to go still further in the spiritualisation of its medium. Or rather, philosophy is precisely that form of thinking which requires no medium at all. Whereas art works through sound, or light, or paint, or words, philosophy as Deleuze conceives it works through nothing other than itself" (Hallward 2006:129). Hallward's reading entails an hierarchical organization in Deleuze's understanding of the relations between science, art, and philosophy that has no textual basis in Deleuze's writings.

organic proteins, cells, proto-life. Such life can only exist and perpetuate itself to the extent that it can extract from the whirling and experientially overwhelming chaos that is nature, materiality, and their immanent forces those elements, substances, or processes it requires, can somehow bracket out or cast into shadow the profusion of forces that engulf and surround it so that it may incorporate what it needs. Henri Bergson, one of Deleuze's major philosophical influences, understands this as a skeletalization of objects: we perceive only that which interests us, is of use to us, that to which our senses have, through evolution, been attuned (Bergson 1988). That is, life, even the simplest organic cell, carries its past with its present as no material object does. This incipient memory endows life with creativity, the capacity to elaborate an innovative and unpredictable response to stimuli, to react or, rather, simply to act, to enfold matter into itself, to transform matter and life in unpredictable ways.

Such elementary life can only evolve, become more, develop and elaborate itself to the extent that there is something fundamentally unstable about both its milieu and its organic constitution. The evolution of life can be seen not only in the increasing specialization and bifurcation or differentiation of life forms from each other, the elaboration and development of profoundly variable morphologies and bodily forms, but, above all, in their becoming-artistic, in their self-transformations, which exceed the bare requirements of existence. Sexual selection, the consequence of sexual difference or morphological bifurcation—one of the earliest upheavals in the evolution of life on earth and undoubtedly the most momentous invention that life has brought forth, the very machinery for guaranteeing the endless generation of morphological and genetic variation, the very mechanism of biological difference itself—is also, by this fact, the opening up of life to the indeterminacy of taste, pleasure, and sensation.[6] Life comes to elaborate itself through making

6. See chapter 3 of Grosz 2004 for a discussion of the indeterminate, sometimes even deranging, effects that sexual selection has on the relentless operations of natural selection and its place in the generation of music, language, and the arts. I have used Irigaray's understanding of an irreducible sexual difference to elaborate and explain Darwin's account of sexual selection: his conception of the

its bodily forms and its archaic territories, pleasing (or annoying), performative, which is to say, intensified through their integration into form and their impact on bodies.

There is much "art" in the natural world, from the moment there is sexual selection, from the moment there are two sexes that attract each other's interest and taste through visual, auditory, olfactory, tactile, and gustatory sensations. The haunting beauty of birdsong, the provocative performance of erotic display in primates, the attraction of insects to the perfume of plants are all in excess of mere survival, which Darwin understands in terms of natural selection: these forms of sexual selection, sexual attraction, affirm the excessiveness of the body and the natural order, their capacity to bring out in each other what surprises, what is of no use but nevertheless attracts and appeals. Each affirms an overabundance of resources beyond the need for mere survival, which is to say, to the capacity of both matter and life to exchange with each other, to enter into becomings that transform each. They attest to the artistic impact of sexual attraction, the becoming-other that seduction entails. This is not a homeostatic relation of stabilization, the build-up and expenditure of libidinal energies that Freud sees as the foundation of orgasmic sexuality, but a fundamentally dynamic, awkward, mal-adaptation that enables the production of the frivolous, the unnecessary, the pleasing, the sensory for their own sake.

Art proper, in other words, emerges when sensation can detach itself and gain an autonomy from its creator and its perceiver, when something of the chaos from which it is drawn can breathe and have a life of its own. Deleuze elaborates the concept of sensation as it was developed in Erwin Straus's *The Primary World of the Senses* (1963), where it designates a relation between a subject and the

capacity to attract sexual partners is fundamentally linked to sexual bifurcation, the bodily differences—whatever they might be—between males and females and the various categories of bodily form all living bodies approximate. It is this difference that attracts, allures, appeals, though it does not do so in predictable or clear-cut ways. It is the indeterminacy of sexual appeal that ensure the processes of evolution are never predictable in advance. It is this indeterminacy that sociobiology and other deterministic branches of evolutionary theory seem unable to embrace.

world preceding rationality and knowledge, perception and intellection, in which there is always a mutual transformation between them:

> The sensing subject does not have sensations, but, rather, in his sensing he has first himself. In sensory experience, there unfolds both the becoming of the subject and the happening of the world. I become insofar as something happens, and something happens (for me) only insofar as I become. The Now of sensing belongs neither to objectivity nor to subjectivity alone, but necessarily to both together. In sensing, both self and world unfold simultaneously for the sensing subject; the sensing being experiences himself and the world, himself in the world, himself with the world.
>
> (STRAUS 351)

Following Straus in seeing sensation as that which becomes, forming one of the links between the subject and the world, Deleuze takes sensation as that which subject and object share, yet is not reducible to either subject or object or their relation. Sensation is what art forms from chaos through the extraction of qualities.

Philosophy, like art and like science, draws on and over chaos. The chaotic indeterminacy of the real, its impulses to ceaseless variation, gives rise to the creation of networks, planes, zones of cohesion, which do not map this chaos so much as draw strength, force, material from it for a provisional and open-ended cohesion, temporary modes of ordering, slowing, filtering. If philosophy, through the plane of immanence or consistency, gives life to concepts that live independent of the philosopher who created them, yet participate in, cut across, and attest to the chaos from which they are drawn, so too art, through the plane of composition it throws over chaos, gives life to sensation that, disconnected from its origins or any destination or reception, maintains its connections with the infinite it expresses and from which it is drawn. Twin rafts over chaos, philosophy and art, along with their more serious sibling, the sciences, enframe chaos, each in its own way, in order to extract

something consistent, composed, immanent, which it uses for its own ordering (and also deranging) resources.[7]

The different arts are a consequence of the various experiments in intensification that have marked sexualized life on earth, conditioned by the (historical) construction of a plane of composition, a plane of shared and differentiating techniques, methods, and resources, a plane transformed and reoriented through the upheavals in art production, the revolutions in sensation that art history, a history encompassing what we usually consider the prehistory of art as well, has wrought. Art is only possible insofar as such a plane precedes any particular work; and each particular work of art finds it place, even the place of disruption, within this plane, without which it could not function as a being of sensation, a sensory variety. The plane of composition, which cuts across and thus plunges into, filters and coheres chaos through the coming into being of sensation, is thus both an immersion in chaos but also a mode of disruption and ordering of chaos through the extraction of that which life can glean for itself and its own intensifications from this whirling complexity—sensations, affects, percepts, intensities—blocs of bodily becoming that always co-evolve with blocs of the becoming of matter or events.

Art and nature, art in nature, share a common structure: that of excessive and useless production—production for its own sake, production for the sake of profusion and differentiation. Art takes what it needs—the excess of colors, forms, materials—from the earth to produce its own excesses, sensations with a life of their own, sensation as "nonorganic life." Art, like nature itself, is always a strange coupling, the coming together of two orders, one chaotic, the other ordered, one folding and the other unfolding, one contraction and the other dilation, and it is because art is the inver-

7. "Art indeed struggles with chaos, but it does so in order to bring forth a vision that illuminates it for an instant, a Sensation. . . . Art is not chaos but a composition of chaos that yields the vision or sensation, so that it constitutes, as Joyce says, a chaosmos, a composed chaos—neither foreseen nor preconceived. . . . Art struggles with chaos but it does so in order to render it sensory" (Deleuze and Guattari 1994:204–205).

sion and transformation of nature's profusion that it too must participate in, and precipitate, further couplings: "if nature is like art, this is always because it combines these two living elements in every way: House and Universe, *Heimlich* and *Unheimlich,* territory and deterritorialization, finite melodic compounds and the great infinite plane of composition, the small and the large refrain" (Deleuze and Guattari 1994:186). Thus the first gesture of art is not, as Nietzsche believed, the exteriorization of one's own bodily forces and energies, the transformation of flesh and blood into canvas and oil but a more primary gesture that requires a body's prior separation from the earth, from nature, from its world. Deleuze understands, and on this point is in remarkable and rare agreement with Derrida, that the first gesture of art, its metaphysical condition and universal expression, is the construction or fabrication of the frame.[8] "Art takes a bit of chaos in a frame in order to form a composed chaos that becomes sensory, or from which it extracts a chaoid sensation as variety" (Deleuze and Guattari 1994:206).

ARCHITECTURE AND THE FRAME

The first artistic impulse in this metaphysical reconstruction is thus not body-art but architecture-art. Art is, for Deleuze, the extension of the architectural imperative to organize the space of the earth. Art, developed alongside of the territory-house and house-territory systems, is what enables the emergence of pure sensory qualities, the data or material of art. This roots art not in the creativity of mankind but rather in a superfluousness of nature, in the capacity of the earth to render the sensory superabundant, in the bird's courtship song and dance, or in the field of lilies swaying in the breeze under a blue sky. It roots art in the natural and in the animal, in the most primitive and sexualized of evolutionary residues in man's animal heritage. Art is evolutionary, in the sense that it

8. See Derrida 1987 and particularly the notion of parergonality he develops there.

coincides with and harnesses evolutionary accomplishments into avenues of expression that no longer have anything to do with survival. Art hijacks survival impulses and transforms them through the vagaries and intensifications posed by sexuality, deranging them into a new order, a new practice. Art is the sexualization of survival or, equally, sexuality is the rendering artistic, the exploration of the excessiveness, of nature.[9]

Art is not linked to some intrinsic relation to one's own body but exactly the opposite: it is linked to those processes of distancing and the production of a plane of composition that abstracts sensation from the body. The emergence of the "frame" is the condition of all the arts and is the particular contribution of architecture to the taming of the virtual, the territorialization of the uncontrollable forces of the earth. It is the frame that constitutes painting and cinema just as readily as architecture; it is the architectural force of framing that liberates the qualities of objects or events that come to constitute the substance, the matter, of the art-work.[10] The frame is what establishes territory out of the chaos that is the earth. The frame is thus the first construction, the corners, of the plane of composition. With no frame or boundary there can be no territory, and without territory there may be objects or things but not qualities that can become expressive, that can intensify and transform living bodies. Territory here may be understood as surfaces of

9. "Perhaps art begins within the animal, at least with the animal that carves out a territory and constructs a house (both are correlative, or even one and the same, in what is called a habitat). The territory-house system transforms a number of organic functions—sexuality, procreation, aggression, feeding. But this transformation does not explain the appearance of the territory and the house; rather, it is the other way around: the territory implies the emergence of pure sensory qualities, of sensibilia that cease to be merely functional and become expressive features, making possible a transformation of function" (Deleuze and Guattari 1994:183).

10. Deleuze and Guattari follow Bernard Cache in seeing architecture as the primordial impulse or form of all of the arts, their modes of forming a plane: "It is possible to define architecture as the manipulation of . . . the frame. Architecture, the art of the frame, would then not only concern those specific objects that are buildings, but would refer to any image involving any element of framing, which is to say painting as well as cinema[], and certainly many other things (Cache 1995:2).

variable curvature or inflection that bear upon them singularities, eruptions, or events. Territory is that which is produced by the elaborate, if apparently useless, activity of construction, attention grabbing, and display that mark most of sexual selection.

Deleuze and Guattari provide a strikingly architectural example for their discussion of the performance of sexual allure or attraction:

> Every morning the *Scenopoetes dentirostris,* a bird of the Australian rain forests, cuts leaves, makes them fall to the ground, and turns them over so that the paler internal side contrasts with the earth. In this way it constructs a stage for itself like a ready-made; and directly above, on a creeper or branch, while fluffing its feathers beneath its beak to reveal their yellow roots, it sings a complex song made up from its own notes and, at intervals, those of other birds that it imitates; it is a complete artist. This is not a synaesthesia of the flesh but blocs of sensations in the territory—colors, postures, and sounds that sketch out a total work of art. These sonorous blocs are refrains; but there are also refrains of posture and color, and postures and colors are always being introduced into refrains: bowing low, straightening up, dancing in a circle and a line of colors. The whole of the refrain is the being of sensation. Monuments are refrains. In this respect art is continually haunted by the animal.
>
> (DELEUZE AND GUATTARI 1994:184)

It is to this extent that architecture, and all the arts that follow from it, are linked to the birdsong, the olfactory dance of insects, the performative displays of vertebrates, including humans: they are each the constitution of a territory, a sexualized territory, the space that is one's own in which one can enact sexual seduction, extract sexual satisfaction, and intensify sexual forces. But, perhaps more significantly, the constitution of territory is the fabrication of the space in which sensations may emerge, from which a rhythm, a tone, coloring, weight, texture may be extracted and moved elsewhere, may function for its own sake, may resonate for the sake of intensity alone. And, equally, insofar as its primordial impulse is the

creation of territory in both the natural and human worlds, art is also capable of that destruction and deformation that destroys territories and enables them to revert to the chaos from which they were temporarily wrenched. Framing and deframing become art's modes of territorialization and deterritorialization through sensation; framing becomes the means by which the plane of composition composes, deframing its modes of upheaval and transformation.

At its most elementary, architecture, the most primordial and animal of all of the arts, does little other than design and construct frames; these are its basic forms of expression. Even in its most sophisticated contemporary forms, architecture is the constitution of interlocking frames, frames that can connect with, contain and be contained by other frames: architecture is the creation of frames as cubes, interconnecting cubes, cubes respected or distorted, cubes opened up, inflected or cut open.[11] The frame separates. It cuts into a milieu or space. This cutting links it to the constitution of the plane of composition, to the provisional ordering of chaos through the laying down of a grid or order that entraps chaotic shards, chaoid states, to arrest or slow them into a space and a time, a structure and a form where they can affect and be affected by bodies. This cutting of the space of the earth through the fabrication of the frame is the very gesture that composes both house and territory, inside and outside, interior and landscape at once and as the points of maximal variation, the two sides, of the space of the earth. Qualities are now loosened onto the world, no longer anchored in their "natural" place but put into the play of sensations that departs from mere survival to celebrate its means and excesses.

11. "Strictly speaking, architects design frames. This can be easily verified by consulting architectural plans, which are nothing but the interlocking of frames in every dimension: plans, sections and elevations. Cubes, nothing but cubes. . . . In a text called 'Déblaiements d'art,' Henry Van de Velde pointed to a parallelism between the historical evolution of the shapes of the frames and that of architectural forms. Paintings would finalize, as it were, the series of frames that make up a building. Through successive unframings, we would pass from the canvas of the painting to the fresco on the wall, to the mosaic on the ground, and finally to the stained glass window in the window frame. Thus the frame of a painting would be residual, or better yet, a rudiment of architectural framing" (Cache 22).

This is why the frame's most elementary form is the partition, whether wall or screen, that, projected downward, generates the smoothness of a floor, that "rarefies" and smooths over the surface of the earth, creating a first (human) territorialization. The floor, ever acquiring smoothness, suppleness, and consistency, makes of the earth and of horizontality a resource for the unleashing of new and more sensations, for the exploration of the excesses of gravity and movement, the conditions for the emergence of both dance and athletics.[12] The partition projected forward induces the wall, which constitutes the possibility of an inside and an outside, dividing the inhabitable from the natural (the chaotic), transforming the earth itself into a delimitable space, a shelter or home. The wall divides us from the world, on one side, and creates another world, a constructed and framed world, on its other side. Though it primarily divides, the wall also provides new connections, new relations, social and interpersonal relations, with those on its other side ("The wall is the basis of our co-existence" [Cache 1995:24]). The wall destabilizes and reinflects the territory created by the floor; yet within and through the wall another reterritorialization of the earth is always immanent.

While its most direct and perceptible function is to separate or divide, the wall equally functions to select and bring in. In this case the frame can be converted into the window, which selectively envisions its natural exterior, now a "landscape," no longer beyond its partition but within the enframed space of the room. It selectively brings in a now framed outside, a view or vista. The wall darkens, keeps out light and natural forces; the window selectively enframes them again to return them to the interior, bringing illumination inside. The wall, floor, and windows each enframe, that is, divide and select both each other and their collective outside; and together— ever approaching the form of the cube even as they eventually come to deform it—they entail a final partition, a roof. The roof, like

12. "It is the flatness of the stage that makes choreography probable, just as it is the flatness of the stadium that increases the probability of athletics. The ground plane rarefies the surface of the earth in order to allow human activities to take shape" (Cache 25).

the floor, though, is more than a horizontal wall, more than a box presented in any orientation whatever. As Cache argues, the roof follows a logic of form more than function: which explains why it tends to belong to a formal, even geometric register—prism, dome, cone, or pyramid (1995:26)—each with their own lines, figures and singularity, with their modes of inflection and curvature.[13]

Within the architectural frame, in miniaturized form, the frame reenacts itself and its territorializing function through furniture, an architecture on the inside of architecture, an architecture of architecture: "Though classified as objects in our everyday language, furniture can be seen as an interior replication of architecture. The closet is a box in the box, the mirror a window onto the outside, the table another floor on the ground." It is hardly surprising that, as Cache—himself a furniture maker—emphasizes, because furniture is that which most intimately touches the body, it is linked to the architectural frame through a direct contiguity with the body and its activities. Furniture enables the body to be most directly affected by, but also protected from, the chaos of every outside: "For our most intimate or most abstract endeavours, whether they occur in bed or on a chair, furniture supplies the immediate physical environment in which our bodies act and react; for us, urban animals, furniture is thus our primary territory. Architecture, object, geography—furniture is that image where forms are fused together" (30).

The real, the outside, nature, matter, force, the cosmos, geography—all terms we can understand as more or less stable expressions of chaos—are that which incites, from the outside, the productive proliferation of resources that reveal or envision an element, fragment, or section of the chaotic in the form of sensation. This real, the outside, chaos, demarcated through the constitution of a (finite and provisional) territory, makes possible the more calculable, measurable, and mappable features that characterize a site, the site's openness to scientific and technical manipulation

13. "The wall delimits and the window selects: such is the frame of probability within which we find the rarefied interval of the floor. It belongs to the regime of causes and of the interval. The roof is of another order: it envelops an event; it is the effect of singularization" (Cache 28).

and control; and the built frame, produced through a regulation and partitioning of orientations in the site, divides and selects that which the territory, now configured as landscape, a view, can directly mark, and illuminate, the inside, the divisions and selections made by groups and communities. And within the built frame, as a frame within a frame within a frame, our bodies and their bodily supports, furnishings, coexist to make of our bodies an abundance of sensations and actions. Furniture brings the outside in, but only to the extent that it itself is extracted and transformed from this outside, stripped down, reworked, refined, in short, an outside now constructed, regulated, inside. In this process of territorialization, deterritorialization, and reterritorialization, the body becomes intimately connected to and informed by the peristaltic movements, systole and diastole, contraction and expansion, of the universe itself. Body and universe, entwined in mutual concavity/convexity, floating/falling, folding/unfolding are directly touched by that outside now enframed, creating sensation from their coming together.

Art is first architectural because its cosmic materials require demarcation, enframement, containment in order for qualities as such to emerge, to live, and to induce sensation. Architecture is the most elementary binding or containment of forces, the conditions under which qualities can live their own life through the constitution of territory. Territory frames chaos provisionally, and in the process produces extractable qualities, which become the materials and formal structures of art. There is no one architecture, no single enframement, no universal technique for territorialization: each form of life, and each cultural form, undertakes its own modes of organization, its own connections of body and earth, its own modes of management of intractable problems that impose themselves on the living.

Cache makes it clear that although what is described above may be regarded as a kind of genealogy of the plane of composition and the art-events that erupt on its surface, it is not the only genealogy, nor the only (historical, cultural) reconstruction of the origins of art. If Western architecture and art, following the claims made by Wöfflin and Worringer, observe this genealogy of planar con-

struction, the construction of order from substance, then it may be that the genealogy of non-Western art follows an entirely different logic:

> The first architectural gesture is acted upon the earth: it is our grave or our foundation. A plane against a surface of variable curvature, the first frame is an excavation. But perhaps this is just the bedrock of western thought. Unlike our western architecture whose first frame confronts the earth, Japanese architecture raises its screens to the wind, the light, and the rain. Partitions and parasols rather than excavations: screens emphasize the void.
>
> (DELEUZE AND GUATTARI 64)

The earth can be *infinitely* divided, territorialized, framed. But unless it is in some way demarcated, nature itself is incapable of sexualizing life, making life alluring, lifting life above mere survival. Framing is how chaos becomes territory. Framing is the means by which objects are delimited, qualities unleashed and art made possible.

ART AND THE EARTH

Architectural framing produces the very possibility of the screen, the screen functioning as a plane for virtual projection, a hybrid of wall, window, and mirror. Painting can be understood, as we shall see in chapter 3, as the transitional passage from the frame to the screen, a movement of growing dematerialization, a movement where the image becomes less and less dependent on a milieu and location, and is itself the complex and enfolded second-order constitution of the frame, this time no longer for the mixed purpose of usefulness and pleasure, but for the generation (and never the reproduction or representation) of sensations. The history of the frame is the evolution of an increasing dematerialization, a territory-wall-painting-window-mirror-screen-becoming.

Like architecture, art is not only the movement of territorialization, the movement of joining the body to the chaos of the universe itself according to the body's needs and interests; it is also the converse movement, that of deterritorialization, of cutting through territories, breaking up systems of enclosure and performance, traversing territory in order to retouch chaos, enabling something mad, asystematic, something of the chaotic outside to reassert and restore itself in and through the body, through works and events that impact the body. If framing creates the very condition for the plane of composition and thus of any particular works of art, art itself is equally a project that disjars, distends, and transforms frames, that focuses on the intervals and conjunctions between frames. In this sense the history of painting, and of art after painting, can be seen as the action of leaving the frame, of moving beyond, and pressing against the frame, the frame exploding through the movement it can no longer contain.[14] Art thus captures an element, a fragment, of chaos in the frame and creates or extracts from it not an image or representation, but a sensation or rather a compound or a multiplicity of sensations, not the repetition of sensations already experienced or available beyond or outside the work of art, but those very sensations generated and proliferated only by art. Framing is the raw condition under which sensations are created, metabolized, released into the world, made to live a life of their own, to infect and transform other sensations.

This is, precisely, the task of all art and, from colors and sounds, both music and painting similarly extract new harmonies, new plastic or melodic landscapes, and new rhythmic characters that raise them to the height of the earth's sound and the cry of humanity: that which constitutes tone, health, becoming, a visual

14. Deleuze himself seems rather contemptuous of postmodernist art, and especially conceptual art, and shows a clear preference for works of high modernism, in painting as in film and music. One of the challenges facing Deleuzianism is how to direct a Deleuzian-inspired analysis to texts and movements for which he himself had little time.

and sonorous bloc. A monument does not commemorate or celebrate something that happened but confides to the ear of the future the persistent sensations that embody the event.

(DELEUZE AND GUATTARI 1994:176)

The artistic release and propagation of sensation, which as we will further consider in the following chapter, is always a mode of resonance or harmonious vibration, an oscillation extracted from the fluctuating, self-differentiating structure of the universe itself used to pace, measure, and provide discernment in a universe in which nothing is self-identical, all substance is movement, modes of contraction/dilation or difference/repetition, and generates not only perceptions, that is, auditory and visual images, but, above all, rhythm. Rhythm explodes auditorily in and as music and visually in and as painting and the visual arts. Rhythm is what connects the most elementary and primitive bodily structures of even the most simple organisms to the implacable movements of the universe itself: art, as music, sculpture, painting, architecture, dance, resonates or transmits force through every structure. This force must be considered not as the product of mankind, an invention that distinguishes the human from the animal, but rather a nonhuman "unlivable Power" (Deleuze 2003:39) that runs through all of life and connects the living in its various forms to the nonorganic forces and qualities of materiality itself.

The visual and sonorous arts capture something of the vibratory structure of matter itself; they extract color, rhythm, movement from chaos in order to slow down and delimit within it a territory that is capable of undergoing a reshaping and a new harmonics that will give it independence, a plane of stabilization, on which to sustain itself. The refrain is how rhythm stakes out a territory from chaos that resonates with and intensifies the body. Territory is always the coming together both of spatiotemporal coordinates (and thus the possibilities of measurement, precise location, concreteness, actuality) and qualities (which are immeasurable, indeterminate, virtual, and open-ended), that is, it is the coupling of a milieu and a rhythm. A refrain is the movement by which the qualities

of a specific territory or habitat resonate and return to form it as a delimited space, a space contained or bounded but nonetheless always open to the chaos from which it draws its force.

Deleuze and Guattari argue that music and literature, much less clearly spatially oriented arts and more clearly oriented to temporal movement, nevertheless can be represented as readily on the model of territorialization and framing as the visual and architectural arts. Music too is framed and involves the extraction of a vibratory rhythm from chaos, which is then placed into the frame constructed of the interchange between the harmonic and the melodic. Vibration becomes harmonic; melody comes to regulate the bringing together, the construction, of a "sonorous" house, of an interchange of vibratory movements:

> The situation of music seems no different and perhaps embodies the frame even more powerfully [than in the visual arts]. Yet it is said that sound has no frame. But compounds of sensation, sonorous blocs, equally possess sections or framing forms each of which must join together to secure a certain closing-off. The simplest cases are the melodic *air*, which is a monophonic refrain; the *motif*, which is already polyphonic, an element of melody entering into the development of another and creating counterpoint; and the *theme*, as the object of harmonic modifications through melodic lines. These three elementary forms construct the sonorous house and its territory.
>
> (DELEUZE AND GUATTARI 1994:189)

A territory is established only once qualities/properties come to have their own resonances, their own forms of repetition and reconstruction; territory is the spatiotemporal configuration and containment of these rhythms and forces. Territorialization is "the act of rhythm that has become expressive, or of milieu components that have become qualitative" (Deleuze and Guattari 1987:315): vibratory rhythms become colored, sonorous, tactile expressions; they contact and cross-fertilize the earth, a specific location or geography, which frames and conditions their extractions as qualities.

At one and the same time, a quality comes to be abstracted from its milieu and a geography comes to be defined as property or habitat: in the constitution of the frame the cosmos is directed, through constructed planes of cohesion, to material transformations and becomings, to remaking the body, intensifying its forces, while investing its milieu in a new configuration of closures and openings.[15] Chaos is both forestalled, framed, and welcomed through a regulated, tolerable if perhaps bracing and transformative, dose.

If painting aims to make every organ function as an eye, if it aims to make the very entrails see, and if music makes every organ and pore of the body function as an ear attuned to rhythm and melody, if, as Deleuze suggests, painting ever more deeply materializes the body while music spiritualizes it, this is because, through the various arts, the body is, for a moment at least, directly touched by the forces of chaos from which it so carefully shields itself in habit, cliché, and doxa, those movements of containment that render only predictable and preproduced sensations, not sensations that announce the future.[16] What painting, music, and literature elicit are not so much representations, perceptions, images that are readily at hand, recognizable, directly interpretable, identifiable, as does the cliché or popular opinion, good sense, or calculation: rather, they

15. As Bogue suggests in his illuminating analysis of Deleuze's writings on the arts, "Art, as the disposition of expressive qualities, is the active agent in the formation of territory and the establishment of the occupant's proprietary identity" (2003a:20).

16. "[Music] strips bodies of their inertia, of the materiality of their presence: it *disembodies* bodies. . . . In a sense, music begins where painting ends, and this is what is meant when one speaks of the superiority of music. It is lodged on the lines of flight that pass through bodies, but which find their consistency elsewhere, whereas painting is lodged farther up, where the body escapes from itself. But in escaping, the body discovers the materiality of which it is composed, the pure presence of which it is made, and which it would not discover otherwise. Painting, in short, discovers the material reality of bodies with its line-color systems and its polyvalent organ, the eye. . . . When music sets up its sonorous systems and its polyvalent organ, the ear, it addresses itself to something very different from the material reality of bodies. It gives a disembodied and dematerialized body to the most spiritual of entities" (Deleuze 2003:47).

produce and generate sensations never before experienced, perceptions of what has never been perceived before or perhaps cannot be perceived otherwise. The visual arts render visible forces that are themselves invisible; the musical arts "render non-sonorous forces sonorous" (Deleuze 2003:48), in short, they extract something imperceptible from the cosmos and dress it in the sensible materials that the cosmos provides in order to create sensation, not a sensation of something, but pure intensity, a direct impact on the body's nerves and organs.

Painting is about rendering the invisible in visible form, and music about sounding the inaudible, each the expression and exploration of the unrepresentable.[17] Art is not the activation of the perceptions and sensations of the lived body—the merging and undecidability of subject and object, seer and seen in a common flesh as suggested by Straus (1963) and later elaborated by Merleau-Ponty (1968), but about transforming the lived body into an unlivable power, an unleashed force that transforms the body along with the world. Deleuze's response to phenomenological readings of the lived body as the site for art production is highly critical, although it is clear that he owes a debt not so much to Merleau-Ponty as to Uexküll (as we shall see in further detail in the next chapter, a phenomenologist or semiotician not of the conscious human subject but rather of the animal), and his understanding of nature as the patterned counterpointing of phenomenologically selected environments: the spider carries within its web a complex picture of the prey it is to capture—its web is a map of and a counterpoint to the fly. Nevertheless Deleuze's criticism of phenomenology is clear: flesh is the field for the elaboration of sensations but cannot be understood as sensation itself. Sensation heralds the nonhuman becomings of mankind, the evolutionary overcoming of man:

17. "Artists are like philosophers. What little health they possess is often too fragile, not because of their illnesses or neuroses but because they have seen something in life that is too much for anyone, too much for themselves, and that has put on them the quiet mark of death. But this something is also the source or breath that supports them through the illnesses of the lived (what Nietzsche called health)" (Deleuze and Guattari 1994:172–173).

in short, the being of sensation is not the flesh but the compound of nonhuman forces of the cosmos, of man's nonhuman becomings, and of the ambiguous house that exchanges and adjusts them, makes them whirl around like winds. Flesh is only the developer which disappears in what it develops: the compound of sensation. (1994:183)

Cosmological imponderables—among the most obvious, the forces of temporality, gravity, magnetism—equally the objects of scientific, philosophical, and artistic exploration, are among the invisible, unheard, imperceptible forces of the earth, forces beyond the control of life that animate and extend life beyond itself. Art engenders becomings, not imaginative becomings—the elaboration of images and narratives in which a subject might recognize itself, not self-representations, narratives, confessions, testimonies of what is and has been—but material becomings, in which these imponderable universal forces touch and become enveloped in life, in which life folds over itself to embrace its contact with materiality, in which each exchanges some elements or particles with the other to become more and other.

It is for this reason that art is not frivolous, an indulgence or luxury, an embellishment of what is most central: it is the most vital and direct form of impact on and through the body, the generation of vibratory waves, rhythms, that traverse the body and make of the body a link with forces it cannot otherwise perceive and act upon. This explains art's cultural or human universality and ubiquity: it is culture's most direct mode of enhancement or intensification of bodies, culture's mode for the elaboration of sensations, and thus culture's most intense debt to the chaotic forces it characterizes as nature. While there is no universal art, no art form, no music or painting, that appeals everywhere in the same way, it is also true that there is no culture without its own arts, without its own forms of bodily enhancement and intensification.

Art is the opening up of the universe to becoming-other, just as science is the opening up of the universe to practical action, to becoming-useful and philosophy is the opening up of the universe to thought-becoming. Art is the most direct intensification of the

resonance, and dissonance, between bodies and the cosmos, between one milieu or rhythm and another. It is that which impacts the body most directly, that which intensifies and affects most viscerally. Through the plane of composition it casts, art is the way that the universe most directly intensifies life, enervates organs, mobilizes forces. It is the passage from the house to the universe, from territory to deterritorialization, "from the finite to the infinite" (Deleuze and Guattari 1994:180), from the body of the living being to the universe itself. What philosophy can offer art is not a theory of art, an elaboration of its silent or undeveloped concepts, but what philosophy and art share in common—their rootedness in chaos, their capacity to ride the waves of a vibratory universe without direction or purpose, in short, their capacity to enlarge the universe by enabling its potential to be otherwise, to be framed through concepts and affects. They are among the most forceful ways in which culture generates a small space of chaos within chaos where chaos can be elaborated, felt, thought.

2

VIBRATION. ANIMAL, SEX, MUSIC

Speaking is a beautiful folly: with that man dances over things.
How lovely is all talking, and all the deception of sounds! With
sounds our love dances on many-hued rainbows.

—FRIEDRICH NIETZSCHE,
THUS SPOKE ZARATHUSTRA

Music acts on human beings, on their nervous systems and their
vital processes. . . . The man inhabited and possessed by this
intruder, the man robbed of self, is no longer himself: he has
become nothing more than a vibrating string, a sounding pipe.

—VLADIMIR JANKÉLÉVITCH,
MUSIC AND THE INEFFABLE

In this chapter I present the outlines of an ontology of music, look-
ing at music's most elementary relations to chaos and to what all
of life somehow extracts from chaos—a sense of the body and the
earth—relations that music shares with all the arts as well as with
science. Each is constituted out of the peculiar and unique relations
it adopts to the most tangible forces of the real, those we live (in re-
lation to the body and the earth) and those that remain unlivable by
us but nevertheless impinge on us (chaos, the unpredictable, forces,
events), which we as living beings have no choice but to address.

Art and science, but equally philosophy, are those products of evolution that have hijacked the intimately adapted nature of individual variation (tested in terms of its survival capacities by natural selection) through the excessive or nonadaptive detours of sexual selection, sexual taste, and erotic pleasure. It may be that we can come to understand the relations between art and science neither as cooperation or as competition but rather as a kind of incommensurable summoning up of the same forces and contingencies through different, possibly untranslatable, goals and techniques. Art and science are not alternatives to each other: art "competes" and "cooperates" only with other art practices, as science, specific scientific doctrines, techniques, and principles, "compete" and "cooperate" only with each other. Each is a practice the living perform on chaos to extract some order and predictability or some force of a concept, quality, or intensity from chaos that it, in turn, gives up to particular types of living being in particular ways. Chaos is not the object of life and its encounters but life's condition and provocation; life is the extension of chaos in directions and forms that go beyond its own inventive and provocative effects. In brief, I hope to understand music as a becoming, the becoming-other of cosmic chaotic forces that link the lived, sexually specific body to the forces of the earth.

Art, science, and philosophy are three relatively autonomous ways to approach chaos. This is not to say that they are three modes of delivering order to chaos, only that each needs to utilize or elaborate some elements, features, or qualities of what goes by many different names within different conceptual frameworks, among them chaos, disorder, unpredictability, force, the infinite, profusion, intensification, materiality without measure, nature without norm that are in excess of the principles by which we attempt to know and regulate them. Chaos is not the absence of order but rather the fullness or plethora that, depending on its uneven speed, force, and intensity, is the condition both for any model or activity and for the undoing and transformation of such models or

activities.[1] This concept of chaos is also known or invoked through the concepts of: the outside, the real, the virtual, the world, materiality, nature, totality, the cosmos, each of which is a narrowing and specification of chaos from a particular point of view. Chaos cannot be identified with any one of these terms, but is the very condition under which such terms are capable of being confused, the point of their overlap and intensification.

Deleuze and Guattari have postulated, beyond the postmodern obsession with representation and discourse, with forms of order and organization, that is, with systems and structures, that philosophy develops nothing but *concepts* to deal with, to approach, to touch upon, harness, and live with chaos, to take a measured fragment of chaos and bound it in the form of a concept. Philosophy is not a philosophy of language, an image of the world or a series of truths mediated through representations, but a philosophy in which language is only as valuable as the work it does, the concepts it produces and circulates, the effects it has on the real, on the outside. Philosophy is one mode of addressing chaos, one way of living with it rather than a way of giving it its true or inner order.

If philosophy is primarily oriented to the creation, elaboration, and development of concepts, according to Deleuze and Guattari, science primarily develops *functions* ("functives," formulae, algorithms) to address and exchange with chaos; and art elaborates, produces, and intensifies *affects* and *percepts* as its mode of response to and contamination by chaos. Philosophy, art, and science are three among the vast planes—Deleuze and Guattari call them "brain-becomings"[2]—we throw over chaos in order to extract an

1. "The first difference between science and philosophy is their respective attitude toward chaos. Chaos is defined not so much by its disorder as by the infinite speed with which every form taking shape in it vanishes. It is a void that is not a nothingness but a *virtual*, containing all possible particles and drawing out all possible forms, which sprung up only to disappear immediately without consistency or reference, without consequence" (Deleuze and Guattari 1994:118).

2. "The brain is the junction—not the unity—of the three planes" (Deleuze and Guattari 1994:208).

element, a quality, a consistency from chaos, in order to live with it. There are no doubt other planes we could also invent—technical, material, organizational, administrative planes—each slowing down, ordering, highlighting those fragments or features of chaos that the living can use for itself according to their principles of organization.

Philosophy invents concepts to create a consistency from chaos, the arts frame or compose chaos so that sensation can be created and proliferate, and science functions to slow down chaos in order to extract from it limits, constants, measurements—variables it can use to generate predictabilities. Each has its own engagements and struggles with chaos, each takes with it little shards of chaos through which it wrenches a consistency, an intensity or a predictability in order to set itself on the other side of chaos, in order to compose, calculate, or conceptualize.

Art, philosophy, and science each erect a plane, a sieve, over chaos, a historicotemporal and mutually referential field of interacting artworks, concepts, and experiments (respectively), not to order or control chaos but to contain some of its fragments in some small space (a discourse, a work of art, an experiment), to reduce it to some form that the living can utilize without being completely overwhelmed.[3] Chaos, the virtual in all its entwined complexity, can be understood as the ongoing possibility of infinite planes, or the plane of all planes that is the condition of every work and the ability of each work to somehow address the others with which it copopulates the plane. Each plane, Deleuze and Guattari suggest, cuts chaos in a different way, through a different angle, which is why each is unique, irreplaceable, and incommensurable with any other, yet why, in some sense, all the planes address similar problems, similar events, and similar forces, why the planes can utilize and develop their connections, the strata they form, with other planes.

3. Deleuze and Guattari insist that the various planes—the plane of consistency or immanence for philosophy, the plane of composition for the various arts, and the plane of reference for the sciences—are the prephilosophical, preartistic, and prescientific conditions for the emergence of philosophical discourses, artistic works, and scientific experiments.

There is an obvious but indirect link between the enjoyment of music (whether performing, participating, or simply listening) and sexual or erotic pleasure. Of all of the arts, music is the most immediately moving, the most visceral and contagious in its effects, the form that requires the least formal or musical education or background knowledge for appreciation, though of course, as with all cultural forms, music cannot be considered universal or culturally unmediated. Along with dance, with which it is closely aligned, music generates movement and activity in the listener/participant. Music has long been recognized as the most seductive of the arts, the one that most immediately enhances a sense of well-being, the art that most directly enchants (or equally infuriates).[4]

Music is central to Charles Darwin's explanation and understanding of the role of sexual selection in the operations of natural selection. Sexual selection, the ability to attract sexual partners (which is not in itself to be conflated with successful reproduction: the aim is sexual relations, even if the most measurable form for sexual success is the generation of offspring), not only works in cooperation with natural selection but at times functions in conflict with it, placing individuals and species in potential danger to the extent that they attract partners. Darwin sees sexual selection commonly but by no means universally in terms of the active but useless competition between males of the same species to attract the attention and discernment of females (or vice

4. Darwin suggests that music is primarily affective: it functions to stir, intensify, enhance affect. Although it has no particular or given emotional content, it produces an intensification of affects, a heightening of muscular forces, a stirring of emotions: "Music affects every emotion, but does not by itself excite in us the more terrible emotions of horror, rage &c. It awakens the gentler feelings of tenderness and love, which readily pass to devotion. It likewise stirs up in us the sensation of triumph and the glorious ardour for war. These powerful and mingled feelings may well give rise to the sense of sublimity. We can concentrate . . . greater intensity of feeling in a single musical note than in pages of writing" (Darwin 1981: 335–336).

versa).[5] Darwin discusses the costs incurred by the peacock for the magnificence of its plumage, the risk of predatory attack, which is precisely commensurate with its ability to attract the dowdier and more safely camouflaged peahen. Sexual appeal imperils as much as it allures; it generates risk to the same extent that it produces difference.[6]

Even at its very origins, evolutionary theory is divided in how it considers music (and the other arts) and whether it sees music as derived from language (and the visual arts as forms of rehearsal for and representations of past battles, hunts, and various struggles for survival) or whether language is seen as an evolutionary outcome of musicality. If music is derived from language, so the argument goes, then music is fundamentally based on natural selection and served the purposes of self-preservation. If, on the contrary, language derives from music, then it may be that music and the arts are the product of sexual selection, the ability to attract a mate. At stake in this discussion, in other words, is the question whether music remains frivolous, part of sexual amusement, or a more serious and necessary rehearsal and preparation for what is life sustaining. Is music what we share with animals, an outcome of our animal heritage; or is it that which distinguishes the human from the animal?

5. It is significant that Darwin is less sexist and heterocentric than his contemporaries and especially his neo-Darwinian followers. He argues that males commonly compete with each other to attract females and that females commonly exert their powers of discrimination, although he admits that it may not be the powers of preference that females exert so much as the powers of distaste. Rather than claim females chose the most attractive males, Darwin suggests that they simply chose the mates least distasteful for them! "The female, though comparatively passive, generally exerts some choice and accepts one male in preference to others. Or she may accept . . . not the male which is the most attractive to her, *but the one which is the least distasteful*. The exertion of some choice on the part of the female seems almost as general a law as the eagerness of the male" (Darwin 1981:273; emphasis added).

6. Zahavi describes this as the handicap principle: whatever bodily form is enhanced through sexual attractiveness imposes a cost on its bearer that is a heightened vulnerability to predation. The more beautiful the peacock's plumage, the more visible it is for all. See Zahavi et al. 1997.

Herbert Spencer, with whom Darwin so strongly disagreed, believed that music was the indirect outcome of the advantages bestowed on language use for survival. As language use developed, its emotional resonances and excited uses particularly emphasized the prosodic or melodic elements of speech, which became gradually uncoupled from words and attached to sounds. Music is a playful but largely epiphenomenal residue of language. For Spenser, and for the entire tradition of social Darwinism that links him to E. O. Wilson and Steven Pinker, language is primarily acquired because of the benefits it bestows on its speakers in terms of their enhanced fitness, that is, their capacity for survival. Music (and poetry) are at best the playful offshoots of language, the ways in which we rehearse, prepare for, and complicate language, which is ultimately a more useful and powerful tool than nonlinguistic communication. Music is considered a kind of excess or remainder left over from language use.

For Darwin himself, however, music precedes language and is the direct result of sexual selection not of natural selection. Its origins lie in its erotic and enticing appeal; language is the normalized adaptation of this primarily sexually elaborated characteristic.[7] Darwin believed that the differences between male and female forms of vocalization, as well as the differences in vocal physiology between the two sexes (male vocal cords are commonly 50 percent larger than female ones) was the direct result of sexual,

7. In a careful footnote, Darwin outlines his difference from Spenser and the strange appeal of his own claim: "Mr Spencer comes to an exactly opposite conclusion to that at which I have arrived. He concludes that the cadences used in emotional speech afford the foundation from which music has developed; whilst I conclude that musical notes and rhythms were first acquired by the male or female progenitors of mankind for the sake of charming the opposite sex. Thus musical notes became firmly associated with some of the strongest passions an animal is capable of feeling, and are consequently used instinctively, or through association, when strong emotions are expressed in speech" (Darwin 1981:336n).

Thus it is the sexual origins of language that explain its affective force, rather than its descriptive or designatory capacities that enable it to refer and transform affects and emotions.

not natural, selection, which explained the differences in cadence and timbre between the sexes:

> Although the sounds emitted by animals of all kinds may serve many purposes, a strong case can be made out, that the vocal organs were primarily used and perfected in relation to the propagation of the species. Insects and some few spiders are the lowest animals which voluntarily produce any sound; and this is generally effected by the aid of beautifully constructed stridulating organs, which are often confined to the males alone. . . . In the class of Mammals . . . the males of almost all the species use their voices during the breeding-season much more than at any other time; and some are absolutely mute excepting at this season. Both sexes of other species, or the females alone, use their voices as a love-call.
>
> (DARWIN 1981:330–332)

He claims that there is something about music that is seductive, even dangerous: music intensifies and excites. Music, like striking coloring or plumage, attracts and allures, it makes one notice, it alerts one to a spectacle, it becomes part of a spectacle. As such, it belongs more to the order of sexual than natural selection. Such displays do not serve to protect the musical creature or to enable it to acquire useful, pragmatic survival skills. Indeed, they may actively endanger it. Nevertheless it is the erotic, indeed perhaps vibratory, force in all organisms, even those without auditory systems, that seduces, entices, mesmerizes, that sexualizes the body, metabolizes organs, and prepares and solicits it for courtship. There is something about vibration and its resonating effects on material bodies that generates pleasure, a kind of immediate bodily satisfaction. For Darwin, this seems as close to a universal postulate as anything he claims: rhythm, vibration, resonance, is enjoyable and intensifying:

> The perception, if not the enjoyment, of musical cadences and of rhythm is probably common to all animals, and no doubt depends on the common physiological nature of their nervous systems. Even Crustaceans, which are not capable of producing

any voluntary sounds, possess certain auditory hairs, which have been seen to vibrate when the proper musical notes are struck. It is well known that some dogs howl when hearing particular tones. Seals apparently appreciate music, and their fondness for it "was well known to the ancients, and is often taken advantage of by the hunters at the present day."

(DARWIN 1981:333)

In short, there is something about vibration, even in the most primitive of creatures, that generates pleasurable or intensifying passions, excites organs, and invests movements with greater force or energy. This force is not directed to survival, to the acquisition of pragmatic skills, except perhaps indirectly; instead it is linked to expression and intensification, to sexual selection, to the increasing differentiation of the sexes from each other and to the operative value of attractiveness and taste in the appeal that individuals of each sex exert (or do not exert) for their desired partners. In affirming the radical distinction between natural and sexual selection—that is, between skills and qualities that enable survival, and those that enable courtship and pleasure, which sometimes overlap but commonly do not—Darwin introduced an excessiveness into the development and transformation of species. Species are no longer natural collections or kinds developed to survive and compete, they are also the a posteriori and ultimately incalculable consequences of sexual taste, appeal, or attraction. Perhaps sexuality itself is not so much to be explained in terms of its ends or goals (which in sociobiological terms are assumed to be the [competitive] reproduction of maximum numbers of [surviving] offspring, where sexual selection is ultimately reduced to natural selection) as in terms of its forces, its effects (which can less contentiously be understood as pleasure in indeterminable forms), which are forms of bodily intensification. Vibrations, waves, oscillations, resonances affect living bodies, not for any higher purpose but for pleasure alone. Living beings are vibratory beings: vibration is their mode of differentiation, the way they enhance and enjoy the forces of the earth itself. Music is "charming"; that is why it survives and why it is so culturally universal:

The suspicion does not appear improbable that the progenitors of man, either the males or the females or both sexes, before they had acquired language, endeavoured to charm each other with musical notes and rhythm. . . . The impassioned orator, bard or musician, when with his varied tones and cadences he excited the strongest emotions in his hearers, little suspects that he uses the same means by which, at the extremely remote period, his half-human ancestors aroused each other's ardent passions, during their mutual courtship and rivalry.

(DARWIN 1981:337)

For Darwin, though not for most of his followers,[8] our appreciation of and orientation toward music is one of the more primitive characteristics of life and is part of man's most ancient animal heritage.[9] Darwin suggests, in terms that perhaps ironically anticipate a feminism of difference, that the elaboration of the voice as an instrument of seduction must have occurred before the human was fully human, and before human cultures became patriarchal, where the female voice exerted a beauty and appeal perhaps as strong if not stronger than that of the male voice. Perhaps the musical manipulation and constitution of timbre, tone, pitch, rhythm, beat, melody holds as much appeal for the human as it does for man's earliest primate ancestors:

So little is known about the use of the voice by the Quadrumana during the season of love, that we have hardly any means of

8. There are of course a number of contemporary exceptions—evolutionary biologists or anthropologists who affirm Darwin's hypothesis about the sexual origins of music and its relative independence from language acquisition. See, for example, Miller 2002.

9. As Darwin suggests, music and song are among the most primordial characteristics the human shares with other primates: "Whether or not the half-human progenitors of man possessed . . . the capacity of producing, and no doubt of appreciating, musical notes, we have every reason to believe that man possessed these faculties at a very remote period, for singing and music are extremely ancient arts. Poetry, which must be considered as the offspring of song, is likewise so ancient that many persons have felt astonished that it should have arisen during the earliest ages of which we have any record" (Darwin 1981:334).

judging whether the habit of singing was first acquired by the male or the female progenitors of mankind. Women are generally thought to possess sweeter voices than men, and as far as this serves as any guide we may infer that they first acquired musical powers in order to attract the opposite sex. But if this is so, this must have occurred long ago, before the progenitors of man had become sufficiently human to treat and value their women merely as useful slaves.

(DARWIN 1981:337)

MUSIC AND THE ANIMAL

I argued in the last chapter that for Deleuze and Guattari, along with Darwin, art does not begin with the exteriorization of one's own body and the creation of materials that are originally corporeal; art begins with the animal, which is itself a conjunction of bodies and bodily forces with territories (1994:183, 184). For Darwin, art is not the productive arrangement of qualities. It is the coupling of disparate elements on different levels, the coming together of bodily forces with the organization of territory. All art begins with the animal, for it is the animal, and not machines, minds, or subjects, that carves territories and bodies simultaneously: minds, machines, subjects are themselves the artistic products of this coupling of bodies and milieus. Art is not the accomplishment of "higher" existence, whether conceived mentally or spiritually, but is an elaboration of the most primitive and elementary fragments of an ancient animal prehistory.

Darwin believes that we cannot explain the emergence of song, or indeed any of the arts, in terms of natural selection alone. While there is some selection in terms of "fitness," that is in terms of survival, this selection is always negative: it eliminates the unfit or the less fit rather than privileging the fittest. Darwin's argument is that music did not evolve through natural selection but primarily through sexual selection. Music has survived, in other words, not because it is reducible to something useful or practically relevant in everyday life, precisely because it is *not* useful but serves the vaguer purposes

of evocative intensification and pleasure. Music develops and survives not because it bestows upon us, its agents and listeners, some direct advantage but because it is pleasing and thus serves to attract others to us and us to others:

> As neither the enjoyment nor the capacity of producing musical notes are faculties of the least direct use to man in reference to his ordinary habits of life, they must be ranked among the most mysterious with which he is endowed. They are present, though in a very rude and it appears latent condition, in men of all races, even the most savage.
>
> (DARWIN 1981:66)[10]

For Darwin, it is perhaps birdsong that most clearly reveals the sexual nature of song, the productive role of sexual selection in the elaboration of the arts, and the mutual entwinement of the arts of decoration, performance, staging, and so on, with each other.[11] Birdsong is for him essentially music, music at its most represen-

10. Darwin finds rare confirmation in the writings of Charles Hartshorne, who agrees that music is useless but overwhelmingly pleasurable: "Bird songs resemble human music both in the sound patterns and in the behavior setting. Songs illustrate the aesthetic mean between chaotic irregularity and monotonous regularity. . . . The essential difference from human music is in the brief temporal span of the bird's repeatable patterns, commonly three seconds or less, with an upper limit of about fifteen seconds. This limitation conforms to the concept of primitive musicality. Every simple musical device, even transposition and simultaneous harmony, occurs in bird music. . . . Singing repels rival males, but only when nearby; and it attracts mates. It is persisted in without any obvious immediate result, and hence must be largely self-rewarding. It expresses no one limited emotional attitude and conveys more information than mere chirps or squeaks. In all these ways song functions like music" (Hartshorne 1973:56).

11. Darwin makes an interesting aside: that it is significant that the vast majority of songbirds are rather plain in their appearance, and the vast majority of exotic and decoratively colored birds do not sing: "'Hence bright colours and the power of song seem to replace each other. We can perceive that the plumage did not vary in brightness, or if bright colours were dangerous to the species, other means would have to be employed to charm the females; and the voice being rendered melodious would offer one such means'" (Darwin 1981:56).

tative, and cannot be seen as a simplified or anticipatory version of human song. It not only contains tones, pitch, melody, tempo, and rhythm, at least in some forms, it also expressed changes in key and forms of variations and improvisation. Some species of birds have been known to have a repertoire of as many as nine or ten songs and a remarkable capacity to add to and change existing melodies.[12] Birdsong, above all, intensifies emotions—fear, anger, joy, and triumph—that birds experience or observe in others. Predominantly a male activity, birdsong remarkably increases during breeding season.[13] As in human song, in birdsong emotions are elaborated and intensified: something like "love" or courtship functions as the most common theme, which tends to confirm its primarily role in sexual functioning.[14]

Birdsongs serve a number of different functions. They highlight and locate the singer within a particular milieu or territory; they signify a particular set of qualities or skills in the singer—loudness, beauty of melody, number of variations; they mark out a territory that is both desirable (for potential suitors) and dangerous (for potential rivals);[15] they are not always restrained to the operations of

12. See Storr 1992:4–5.
13. "With birds the voice serves to express various emotions, such as distress, fear, anger, triumph, or mere happiness. It is apparently sometimes used to excite terror, as with the hissing noise made by some nestling birds. . . . The true song, however, of most birds and various strange cries are chiefly uttered during the breeding season, and serve as a charm, or merely as a call-note, to the other sex" (Darwin 1981:51–52).
14. "Nearly the same emotions, but much weaker and less complex, are probably felt by birds when the male pours forth his full volume in song, in rivalry with other males, for the sake of captivating the female. Love is still the commonest theme of our own songs" (Darwin 1981:336).
15. Darwin asserts that the season of love is also that of battle (1981:48), and that coupled with or as the underside of the elaborate courtship rituals related to the attainment of a sexual partner is not an actual rivalry with members of the same sex and species, but at least the semblance or representation of a rivalry. Although there is sometimes fierce competition between rivalrous males in courtship competitions, Darwin affirms that many of these relations, particularly within bird species, seem more directed to the attention of female observers than to engaging in any real and dangerous rivalry with other males. The rivalry is often in part directed to its audience (see Darwin 1981:50).

the voice itself, for as Darwin himself recognized, birds and other animals more generally are capable of generating a diverse range of sounds, both vocal and "instrumental" (Darwin mentions peacocks and birds of prey rattling their quills or moving their wings rapidly [Darwin 1981:61–62]). He talks of the mesmerizing and appealing power that birdsong exerts not only for members of the same species and opposite sex but also for other species, including mankind:

> There can be no doubt that birds closely attend to each other's song. Mr. Weir has told me of the case of a bullfinch which had been taught to pipe a German waltz, and who was so good a performer that he cost ten guineas; when this bird was first introduced into a room where other birds were kept and he began to sing, all the others, consisting of about twenty linnets and canaries, ranged themselves on the nearest side of their cages, and listened with the greatest interest to the new performer.
>
> (DARWIN 1981:52)

There are a number of ways in which birdsong resembles human music: birdsongs (along with the most sophisticated animal music—the music of whales) are commonly learned rather than innate, a melodious movement of tones rather than a fixed repertoire of signals. Because they are commonly learned, this means that the songs performed are capable of being spontaneously modified, either through the addition of new learned elements or through the modification of existing elements. Like humans, birds (and whales) are particularly susceptible to learning new songs and new musical elements the younger they are, and their range of improvisational skills depends on when they acquire new sounds and calls. Although Darwin insists on their similarity and the possibility of developing a more elaborate conception of song using the elementary fragments of birdsong elaborated step-by-step into a more complex melody ("It is not difficult to imagine the steps by which the notes of a bird, primarily used as a mere call or for some other purpose, might have been improved into a melodious love-song" [1981:66]), most evolutionary theorists today tend to see human song and birdsong

(and whale song) as elements of convergent evolution rather than as gradual steps in the linear development of music.[16]

It is clear that there is no direct line of development between birdsong and human music, for there is no line between the bird and the human: my claim is not that the bird influences the human, but that the songbird (and the songs of whales) accomplishes something new in its oratory, a new art, a new coupling of (sonorous) qualities and milieus that isn't just the production of new musical elements, materials—melodies, rhythms, positive music contents—but the opening up of the world itself to the force of taste, appeal, the bodily, pleasure, desire—the very impulses behind all art.

What music and the arts indicate is that (sexual) taste and erotic appeal are not reducible to the pragmatic world of survival, although of course subject to its broad principle as a limit: they indicate that those living beings that "really live," that intensify life—for its own sake, for the sake of intensify or sensation—bring something new to the world, create something that has no other purpose than to intensify, to experience itself. Music and art are the opening up of the pragmatic world of performed and judged actions to qualities, the opening up of life to taste, to sexuality, to erotic appeal, to excessiveness. While it is the world of nature that is central to the operations of music (in ways that are commonly not recognized by evolutionary scientists), it may be that there is a less literal connection between them than either imitation or linear development. It may be that, if we follow the movement not only of those creatures who produce sonorous arts but of that counterpoint that is nature and its various conjunctions, then the natural world can itself be construed as musical, as the playing out of a certain number of musical themes, the movement of duets, trios, quartets, orchestras to create natural sonatas, love songs, requiems.

Perhaps this music of nature is itself acted out, performed not only in the constitution of human musicality and the adoption of

16. See, as one of the critics of Darwin's postulate of the nonhuman origins of music, Steven Mithen's *The Singing Neanderthals* (2005).

formal principles of composition and performance but also in the contrapuntal relations between the very bodily schema and its lived milieu that is enacted in nature itself. In other words, is it not the case that the voice and the ear in human subjects are contrapuntally tied to each other? Is not the ear itself a refrain that is continually deterritorialized by the voice?[17]

NATURE AS COUNTERPOINT

The writings of the Estonian biosemiotician Jakob von Uexküll have been influential both on those working on the lifeworld, the *Umwelt,* of particular species of animal (in a sense his work can be considered the earliest attempt to develop a phenomenology or a biosemiology of animal life) and particularly on the writings of Deleuze and Guattari, who use his work to develop an account of the centrality and species-specific notion of milieu in understanding the ways in which particular species experience their lifeworlds. Species cannot be understood as entirely separable from the milieus in which they find themselves, for these milieus are involved in a kind of coevolution. Uexküll discusses what he understands as the "musical laws of nature" [*Weltgesetz,*] the "laws" binding together the development, or, rather, coevolution, of the spider and the fly, the tick and the mammal, the wasp and the orchid, the snapdragon and the bumblebee, "each of which serves as a motif for another. Nature as music. . . . A melodic or rhythmic plane" (Deleuze and Guattari 1987:314). For Uexküll, music is not just a useful metaphor for understanding highly context-specific relations between living elements within given milieus, it is a literal form by which nature can be understood as dynamic, collective, lived rather than just fixed, categorized, or represented.

Uexküll argues that an animal is not immersed wholesale in a given milieu, but at best engages with certain features that are of significance to it, that counterpoint, in some sense, with its own organs.

17. "The ear is itself a refrain, it is shaped liked one" (Deleuze and Guattari 1987:302).

Each organism in every species is surrounded by its Umwelt, an "island of the senses" (Uexküll 2001a:107) that is always a considerable simplification of the information and energy provided by any milieu. The Umwelt of the organism is precisely as complex as the organs of that organism—Uexküll advocates an extreme perspectivism in which objects are not autonomous or independent sets of qualities and quantities, but opportunities for engagement that offer themselves in particular ways to particular organs and remain otherwise indiscernible.[18] Organisms are sense-bubbles, monads composed of coextensive overlapping beings and fragments of milieus, enclosing and carrying with them elements, one might even understand them as musical counterpoints, that are only given outside, to which the organism is itself a brilliant and inventive response.

Perhaps Uexküll's best known example, the one Deleuze repeats in a number of his writings, is that of the tick in its Umwelt. The tick is blind, deaf, and mute. It sees and hears nothing; at most it feels temperature through its photosensitive skin and has an acute but highly focused sense of smell. After the female tick has mated, she moves up a twig or branch toward the light, which serves to position her so that she may access the body of a mammal, whose warm blood she needs to feed on. Her organs of smell are well developed, oriented to discern only one particular smell, that of butyric acid, an odor common to all mammals in their sweat. When this odor passes below the leaf or stick on which it is perched, the tick falls on the skin, seeks a spot more or less free from hair, and proceeds to suck its blood. The warmth of the animal is a trigger for the tick to begin sucking, which engorges the tick with blood. Bloated to the size of a pea, it drops off the animal, deposits its eggs, dies, and the tick's life cycle begins again.

18. "Every object becomes something completely different on entering a different Umwelt. A flower stem that in our Umwelt is a support for a flower, becomes a pipe full of liquid for the meadow spittlebug (Philaenus spumarius) who sucks the liquid to build its foamy nest. The same flower stem becomes an upward path for the ant, connecting its nest with its hunting ground in the flower. For the grazing cow the flower stem becomes part of a tasty morsel of food for her to chew in her big mouth" (Uexküll 2001a:108).

Traditional physiological or biological accounts would suggest that these actions are made of reflexes, automatic reactions to a given stimulus, an unleashing of pregiven behavioral cues. But for Uexküll what is significant is that the tick is responding to perceptual signs, significances, rather than causal impulses.[19] The tick's world is made up of three affects—the smell of butyric acid, the warmth of the sun and the mammal's skin, and the taste of blood. The tick and the mammal create a kind of provisional totality, a bubble-world: the mammal is the tune whose melody the tick has to play. It cannot discern the qualities of the mammal it falls on, it cannot perceive the vast bulk of information that even the branch it alights on could provide some differently structured organism. The tick lives in a simplified world, a harmonic world of its own rhythms and melody, a melody composed by its Umwelt, the conjunction mammal-twig-sun, in which it is a connective, an instrument. Each animal is itself a kind of creative response—an improvisation of a score that is provided by its Umwelt: "Every Umwelt of a normal animal is a faultless composition of nature—you have only to understand how to look for its themes and its notes" (Uexküll 2001a:120).

Or take the case of the honeybee. It too lives in a profoundly simplified world, a world of vision and smells, in which it can only discern two kinds of visible shapes—the cues for opened and closed forms, round and semicircular shapes, that will enable it to distinguish flowering from closed buds and the cues for four basic colors—ultraviolet, blue, green, and yellow. It also lives in a world overwhelmed by many different kinds of smells, the perfumes of many flowers. Uexküll argues that if we adequately understand the theme of its Umwelt, we can understand the nature and form of its perceptual cues, its forms of attunement to its milieu, that is, its active selection of those milieu elements that signify for it. The

19. "We are not concerned with the chemical stimulus of butyric acid, any more than with the mechanical stimulus (released by the hairs), or the temperature stimulus of the skin. We are concerned solely with the fact that, out of the hundreds of stimuli radiating from the qualities of the mammal's body, only three become the bearers of receptor cues for the tick" (Uexküll 1957:11).

melody the honeybee performs is that of its flowers, the flowers' life cycle, of which it is an active part:[20]

> The theme of the music for the honeybee is the collection of nectar and pollen. To find them the path that leads to them has to be marked with perceptual cures. This explains the choice of properties of flowers that become form, color, smell, and taste perceptions to the bees. A honeybee meadow is something very different from a human meadow. It is a honeybee composition made up of bee notes.
>
> (UEXKÜLL 2001a:120)

For Uexküll, the music of nature is not composed by living organisms, a kind of anthropomorphic projection onto animals of a uniquely human form of creativity; rather, it is the Umwelten, highly specifically divided up milieu fragments that play the organism. The organism is equipped by its organs to play precisely the tune its milieu has composed for it, like an instrument playing in a larger orchestra. Each living thing, including the human, is a melodic line of development, a movement of counterpoint, in a symphony composed of larger and more complex movements provided by its objects, the qualities that its world illuminates or sounds off for it. Both the organism and its Umwelt taken together are the units of survival. Each organism is a musician completely taken over by its tune, an instrument, ironically, only of a larger performance in which it is only one role, one voice or melody.[21]

20. "The number and nature of perceptual cues can to a certain extent be predicted as soon as one knows the theme of the music (Lebensmusik) that the Umwelt of the animal is playing" (Uexküll 2001a:120).

21. The idea of the organism as a melodic counterpoint to its milieu, the milieu that comes to compose its territory is elaborated through many examples in Uexküll's writings. For example: "The dependence of the cellular musicians on the tune was already evident from the sea urchin experiments by Driesch. Cutting the embryo of the sea urchin in half reduced the number of cells to half but did not change the building tune. This was continued by the other half. This applies to all orchestras. When half the musicians leave, the other half of the orchestra goes on playing the same tune. Spemann reports an astonishing experiment. Inserting frog cells, that normally evolve

Its milieu is not a determinant in the elaboration of the qualities of the organism, which emerge randomly; rather its milieu is an ongoing provocation to the organism to utilize its randomly emergent qualities maximally. The organism is a provisional response to that provocation: it generates as many senses, organs, actions as it is capable of using to extract what its body needs and can harness from this highly stylized environment. It is not an effect or product of its environment, but is a master of its Umwelt, through which it can occupy and be part of an environment. The organism is not a reaction to a milieu now regarded as stimulus: rather, the milieu is a pregiven counterpoint with which the living being must harmonize if it is to survive, to recognize its food, its enemies, its possible partners.

One final example may help make this clear. Uexküll discusses the production of the spider's web as a kind of spatial counterpoint to the movements of the fly. The web is not entirely comprehensive, and its form is not adequately explained unless we understand its relation to the fly. The threads of the web must be both strong enough to capture the spider's prey, yet invisible enough for the prey to be unable to see them. There are, for example, two kinds of thread in every web: smooth radial threads that the spider is able to stand on and spin from and sticky parallel threads that function to catch flies (or other prey). The size of the net, its holes and gridding, is an exact measure of the size of the fly. The fly is contrapuntal to the web—or, equally, the fly, the web, and the spider form a unique coupling, a milieu qualitatively inducing and selected for specific pairings, specific productions. The "properties of lifeless things" like the web "intervenes contrapuntally in the design of living things" (Uexküll 2001a:122). For Uexküll, it is significant that not only can relations between an organism and its Umwelt be taken as a musical symphony, the very evolutionary relations—the

into frog brain, in the mouth area of a triton larva, the insert obeys the mouth building tune of the triton larva, however, it does not become a triton mouth but the mouth of a tadpole, true to its origin. One could do a similar experiment with a strong orchestra. When replacing the violins with horns in a certain movement, the orchestra can go on playing the same tune but with a very different tonal quality" (2001a:121).

relations that explain both natural and sexual selection—can also be conceived as part of a natural musical order. Male-female relations, the relations of sexual difference and sexual selection, for example, are interwoven as duet, as the blending of two different melodies and rhythms into a single composition: "the male-female duet is a theme that is interwoven in a thousand variations into the orchestration of the living world" (Uexküll 2001a:118) and "Nobody will deny that males and females are composed in counterpoint through nature." (Uexküll 2001a:122).

If nature can be seen as the contrapuntal relation between at least two biologically connected musical themes, the harmonious note-by-note connections between at least two different melodies, then milieu or environment is not entirely separate from or outside the living organism: it is already mapped or composed in terms of the musical cadences available to that body. The fly is already mapped, signaled, its place accommodated in the spider's bodily behavior before any particular spider has encountered any particular fly. The melody plays on, seeking the instruments it needs to continue its rhythms, pacing, harmonies: what remains central, though, is not finding precisely the right instrument for each musical movement, but continuing to play with whatever is at hand, a kind of musical bricolage in which the central musical themes must be played and in which the very bodies of organisms are the instruments.

MILIEU AND TERRITORY

What is it that constitutes music or indeed any of the arts? We have already suggested that it is the coupling of two disparate orders, those of bodily affects or percepts and those governing the geology of the earth or territory: art is always the coupling of extracted elements from the cosmological order and their integration into the lived experience and behavior of organisms. Art is of the animal to the extent that art is the consequence, the unexpected, unpredictable effect, of the coupling of a milieu or territory with a body, and the extraction of qualities, whether sonorous, visual, or tactile, framed through the constitution of a (history of) form.

We have already mentioned the relations between the arts, sciences and philosophy and chaos: our immersion in chaos and the various attempts that humanity has undertaken to organize, structure, and map elements of this chaos have only most recently led to the elaboration and development of these knowledges and social practices. More primitively, chaos has divided itself, through the elaboration of life, into precisely the Darwinian units that define individual variation (the living individual, variable subspecies, and heterogeneous species) and natural selection (the environment, the ecological niche, the milieu, a territory). Yet, as Uexküll has shown us, the operations of evolutionary elaboration entail that the organism of individual variation already contains within itself something of the score or resonance the milieu has chosen to highlight and perform through this organism.

In order to explain this ontology of music, it is necessary to discuss the movement by which the whirling chaos of forces that constitute the cosmological order are slowed down, minimally structured, delimited, named, charted, harnessed. The earth is the region of chaos in which all known life abides. It is the most ordered yet intimate location and frame for the structuring of behavior. But the earth itself, at least as far as each species is concerned, is nothing but an abstraction, for the bulk of energies, forces, movements that constitute the earth as a totality are indiscernible to particular lifeforms, which at best perceive and access only those elements or fragments available within a limited geographical and meteorological range. If the earth is the cosmological frame for all terrestrial life, no form of life lives on the earth per se. Each living thing inhabits only a region of the earth, a delimited location, a milieu, a small always locatable zone within a larger surrounding region.

A milieu, though, is not yet a territory. A milieu is what the fly inhabits, an indeterminable but limited space highlighted through significant elements or qualities—cues to prey, rivals, love objects, and so on. For Deleuze and Guattari, art only emanates from the conjunction of a *territory* and qualities, and a milieu is not yet a territory, although it provides it with most of its characteristic features. The spider together with its milieu constructs a territory whose emblem or placard is its web. It is from a milieu that a ter-

ritory is drawn, and we have learned from Uexküll to what extent a milieu imprints itself as the counterpoint of bodily organs and processes. A territory is the delimitation of a milieu in accordance with the force of a rhythm, it is the rhythmic alliance of a limited milieu and a restricted range of bodies and body movements.[22] Both rhythm and milieu are the slowing down, the provisional formalization of elements of chaos: a milieu, the congealing of a block of space-time, and a rhythm, the emergence of a periodicity, are not separable from the block of emergent territoriality.

A territory is the delimitation of a milieu or sometimes even the compression and compaction of a number of different milieus. It is an external synthesis, a bricolage, of geographical elements, environmental characteristics, material features, shifted and reorganized fragments from a number of milieus (chaos itself is nothing but the milieu of all milieus), that create both an inside, an outside, a passage from the one to the other, and a space that is annexed, outside, contestatory, a resource: a cohesion inside, a domain outside, doorways from one to the other and energy reserves to enable them to reconfigure or reorchestrate themselves.[23] Which is another way of saying that without the unpredictable juxtapositions brought about by life there could be no territories, and no milieus but only chaos, only the outside. Only when those fragments or elements of milieus—colors, shapes, materials, plants, geographical features—cease to operate functionally, causally, predictably, that is, cease to be regulated in their relations to living beings by natural selection alone, do they become expressive, acquire rhythm, or become dimensional (Deleuze and Guattari 1987:315). In other words, it is only when a rhythm and a milieu cohere, form internal

22. "The territory is in fact an act that affects milieus and rhythms, that 'territorializes' them. The territory is the product of a territorialization of milieus and rhythms" (Deleuze and Guattari 1987:314).

23. "A territory borrows from all milieus; it bites into them, seizes them bodily (although it remains vulnerable to intrusions). It is built from aspects or portions of milieus. It itself has an exterior milieu, an interior milieu, an intermediary milieu and an annexed milieu. It has the interior zone of a residence or shelter, the exterior zone of its domain, more or less retractable limits or membranes, intermediary or even neutralized zones, and energy reserves or annexes" (Deleuze and Guattari 1987:314).

relations with each other, induce each other to come together, the rhythm functioning now as that particular temporal form of a region, that a territory can emerge, that the raw materials of art can erupt and the processes of deterritorialization, which are the condition of art, can begin. Territory enables new functions to erupt and new forces to regroup.

Territory and quality are two sides of the one movement: neither can exist without the resonating of a milieu or region with a rhythm. Territory is not the background or context for the eruption of sensory qualities, marks, significations, in the language of Uexküll, but rather it is the mark, sensations, qualities, that enable a territory to appear: "Territorialization is an act of rhythm that has become expressive, or of milieu components that have become qualitative" (Deleuze and Guattari 1987:315).Territory is artistically inscribed, the consequence not of a naturally selected "territorial imperative" but of an artistic movement: the creation of a marker. The first artist, for Deleuze, is the architect, the one who distinguishes inside from outside, who draws a boundary, as we have discussed previously. This boundary is not self-protective but erotico-proprietorial: it defines a stage of performance, an arena of enchantment, a mise-en-scène for seduction that brings together heterogeneous and otherwise unrelated elements:[24] melody and rhythms, a series of gestures, bows, and dips, a tree or a perch, a nest, a clearing, an audience of rivals, an audience of desired ones.

Territory operates according to a double imperative: a proprietorial relation to a piece of the earth and a qualitative relation to properties unleashed or newly available. Expressive properties and detachable qualities: "A milieu component becomes both a quality and a property, *quale* and *proprium*" (315). Rhythm, which is

24. "The artist: the first person to set out a boundary stone, or to make a mark. Property, collective or individual, is derived from that, even when it is in the service of war and oppression. Property is fundamentally artistic because art is fundamentally *poster, placard*. As Lorenz says, coral fish are posters. The expressive is primary in relation to the possessive: expressive qualities, or matters of expression, are necessarily appropriative and constitute a giving more profound than being" (Deleuze and Guattari 1987:316).

the differential relation between different milieus, creates territories and expressive qualities, marking possession. The brilliant coloring of certain birds, which Darwin notes tends to imply their poor singing abilities, distinguish territorial birds from gregarious yet plainly colored birds. It is almost as if each bird can only contain so much intensity, sonorous or visual, and no more, that it can entice and seduce in one particular way rather than in many. Singing is clearly as much a territorial marker as coloring: they are each forms of allure, but an allure that can only exert its effects in a space-time marked off from other spaces and from the dangers and distractions of other species, predators, and rivals for one's own species.[25] Their markings, their sonorous abilities, are the qualities that unleash, and are unleashed by, the attainment of a territory.

It is significant, and particularly ironic, that among the most continuously surviving native peoples living today, the traditional indigenous groups inhabiting the central western desert in Australia, there is an explicit awareness of the interplay between the constitution of a territory and the eruption of the refrain and its impulse to becoming-music, as if humans did maintain an unbroken connection with the territoriality of the animal, and based their own on the extent to which the human can become-animal. It is this that may account for the so-called songlines outlined in Bruce Chatwin's remarkable text of the same name (1987) that compellingly describes, from the point of view of a "European" outsider, traditional Aboriginal people's relation to their land, a relation that is indeed marked by possession or stewardship, even though it cannot be construed as private property. It is because there is a direct connection between the forces and features of the earth and those that produce the body, it is because the earth is already directly inscribed contrapuntally in the body, that the body can sing the

25. "Territory is first of all the critical distance between two beings of the same species: Mark your distance. What is mine is first of all my distance; I possess only distances. Don't anybody touch me, I growl if anyone enters my territory, I put up placards. Critical distance is a relation based on matters of expression. It is a question of keeping at a distance the forces of chaos knocking at the door" (Deleuze and Guattari 1987:319–320).

earth and all its features, which both mark these features as theirs to preserve and look after, but also mark their debt to and affinity with the earth and its particular qualities. The songlines are those lines that cut through and inscribe both the earth and the bodies that abide there; they are the resonating lines of force that separate and then join a people to a territory, to movement through a territory, as we shall elaborate in further detail in the next chapter.

Totemic ancestors, while traveling across the country during the prehistoric Dreamtime, would sing out the names of everything they came across—every living thing, plants and animals, every natural feature, river, mountain, valley, literally singing the territory into existence. This trail of words, rhythms, and melodies, along with dance and painted forms, religious and cultural rituals, commemorates and celebrates this primordial origin—the origin of territory out of natural milieus and chaotic forces, the origin of bodies, individual bodies and the bodies of a people marked by and tied to this territory: "In theory, at least, the whole of Australia could be read as a musical score. There was hardly a rock or creek in the country that could not or had not been sung" (Chatwin 1987:13). The land itself, indigenous territories, indeed all the territories of all groups, are mapped through song and as song, a song that cannot be sung in front of enemies or rivals, a song with the power to affect the land and other groups. A song sings the earth and signs a body, a song brings a body to earth and the land to the body, enabling one to touch the very core of the other, singing the story of a past while bringing about a new future, a new marking of the earth, a new inscription of bodies and territories.[26] Lest this be construed as a romantic "orientalism," a story that refers only to a romanticized native other, it needs to be made clear that the occupation of ter-

26. The song, the name, the very resonance of language is directly tied to a land and a body. To honor those who have died, who can no longer speak or sing, Aboriginal peoples will no longer speak the name of the deceased or must refer to them by some other name: "When someone dies, Australian Aborigines cease pronouncing the name with which the person was hailed and addressed, and if the person had done paintings, museum curators of collections of Aboriginal art will have to remove paintings bearing that name from public display" (Lingis 2007:19).

ritory, whether the consequence of war or stewardship, requires a kind of binding of bodily forces to the natural forces of a territory that music best accomplishes: music has led troops into countless wars and has stirred numerous past and present patriotic, as well as resistant, hearts. Indeed a history of war music, of music used to stir and reinforce patriotism, of music that can induce all the warrior forces of a body, is still waiting to be written. Every people sings the earth and their own bodies into existence only by identifying those earthly elements that tie into or counterpoint their bodies and bodily needs: the earth, however rarefied and abstracted, still marks every body and is the condition for every body's artistic capacities. It is because the earth frames and engulfs the body that the body can sing the earth and the stories of its origin.

THE REFRAIN, MUSIC, AND VIBRATION

A living organism is a material organization that is sensitive to and makes vibratory rhythm part of the operation of its organs.[27] The tapping a child makes in wandering around aimlessly, the humming we sometimes unconsciously perform as we anxiously wait for something or someone, the small piece of annoying music that sticks in our heads despite our loathing it—these are all version of the refrain, a small capture of melodic and rhythmical fragments that, while they are not the raw materials of music, are the con-

27. The first vocalizations in any articulated life are those of a cry: sobbing, gulping, breathing with a more and more intense rhythm. Pain articulates itself in many creatures, even those without vocal apparatus in roars, hisses, screams and squeals. For Lingis, expression is bound up with the rhythmic forces inhabiting and transforming bodies, the pleasures and pains the body comes to articulate: human infants laugh and weep before they can speak, and they laugh and "weep with one another's laughter and tears. Human infants, and now biologists, recognize that that chimpanzees, prairie dogs, and rats laugh. The distinctive colors, patterns, and cries that individuals recognize and that are attractive to others of their kind may also attract individuals of another species. Golden pheasants join flocks and courtship circles of Lady Amherst pheasants; buffalo have mated with yaks, lions with tigers, bottlenose dolphins with false killer whales" (Lingis 2007:69).

tent of music and are what music must deterritorialize in order to appear.[28] The refrain prevents music while at the same time being the smallest anticipation of a music to come.[29]

The refrain is a kind of rhythmic regularity that brings a minimum of livable order to a situation in which chaos beckons. It is the tapping out of a kind of order of safety that protects the body through the rhythms of the earth itself. To repeat, every refrain, for Deleuze and Guattari, has three basic components: first, a point of order or inside—a home, nest, or space of safety that filters out or keeps the forces of chaos temporarily at bay ("A child hums to summon the strength for the schoolwork she has to hand in" [311]); second, a circle of control that defines not only a safe inside but also a malleable or containable outside, a terrain to be marked, a field to be guarded (a cat sprays strategic objects at the boundary of its territory, a bird marks the field below its nest as the space of its sonorous and rhythmic performance); and, third, a line of flight to the outside, a movement of migration, transformation, or deformation (the long march of lobsters across the ocean floor, the path of migratory ducks or monarch butterflies flying north or south each year; 1987:311–312).[30] Every refrain is

28. It is because it is unclear whether the refrain is the condition of music or an impediment to music, and because pop music is considered automatic or programmed music, that there is within Deleuzian circles something of a debate regarding the status of pop music. In addition to Buchanan 2000; Buchanan and Swiboda 2004; see also Bogue 2003a, 2003b.

29. "We are not at all saying that the refrain is the origin of music, or that music begins with it. It is not really known when music begins. The refrain is rather the means of preventing music, warding it off, or forgoing it. But music exists because the refrain exists also, because music takes up the refrain, lays hold of it as a content in a form of expression, because it forms a block with it in order to take it somewhere else" (Deleuze and Guattari 1987:300).

30. "Hearing distant melodies, we can set forth from the zone we inhabit, never to return. Salmon at breeding season leave the territories where they live and return to where they were born to lay their eggs and die. Periodically the lobsters of the Caribbean march off in single file into the open ocean; biologists believe that their long march follows the advance of glacial periods on Earth, the last one ten thousand years ago. Migratory birds, responding to the seasonal tilting of Earth in its orbit, follow the lines of the Earth's magnetic field" (Lingis 2007:15).

marked by all three aspects or movements, a home, a yard, and a way out, which nevertheless vary in their incantatory force, in their combination, in their emphasis.

Music submits the refrain to the process of deterritorialization, removing it from the place of its "origin" and functionality, enabling the refrain to free itself from a particular place, purpose, rhythm or force: "Music is a creative, active operation that consists in deterritorializing the refrain" (300). Music, whose vibratory force is perhaps more immediate, more visceral, more neural than all of the other arts, consists in deterritorializing the voice, deterritorializing sound, making each resonate with a different set of vibrations than those (chaotic forces) the refrain attempts to ward off. The refrain wards off chaos by creating a rhythm, tempo, melody that taps chaos by structuring it through the constitution of a territory and a mode of occupation of that territory, a musical frame. It is only when the territorial organization is itself upset, reconfigured, and abstracted through autonomous qualities that music can work its intensifying effects on individual and collective bodies.[31] Only then do rhythms become detached from their functional role and operate instead as expressive qualities, seeking to resonate not only from within the territory from which they are extracted but outside, elsewhere, in the world beyond. Music is a line of flight from the home that the refrain constructs. The tick and the mammal whose blood it extracts, the spider and the fly it captures, are contrapuntal or harmonic forces, dueting features that must be considered as part of one and the same refrain. In this

31. "Music seems to have a much stronger deterritorializing force, at once more intense and much more collective, and the voice seems to have a much greater power of deterritorialization [than art or the face, which it deterritorializes]. Perhaps this trait explains the collective fascination exerted by music, and even the potentiality of the 'fascist' danger . . . : music (drums, trumpets) draws people and armies into a race that can go all the way to the abyss (much more than banners and flags, which are paintings, means of classification and rallying). It may be that musicians are individually more reactionary than painters, more religious, less 'social'; they nevertheless wield a collective force infinitely greater than painting" (Deleuze and Guattari 1987:302).

sense, although they are musical, they stop short of being music. They produce a differential rhythm, a kind of melody but not yet music, which requires the deterritorialization and deframing of the refrain to move it out of the circle of existence regulated by natural selection and into a line of flight toward the world of autonomous qualities regulated by sexual selection.

Refrains, then, are rhythmic, melodious patterns, small chants, ditties, that shape the vibrations of milieus into the harmonics of territories, the organization of a wall or barrier. Music is the reverse movement, the liberation of these harmonic and rhythmic patterns from their originating location and their placement into a double movement, both musically, beyond the smallness of the refrain and on, to the song, the tune, the sonata, the duet, the symphony, other forms of music, genres, and so on, to forms as yet not even conceivable on the plane of composition; and spatio-temporally, beyond territory, to individuals, peoples, races, bodily movements, performances.

What seems to be transmitted, transformed, located, and relocated in this dance of forces that moves from chaos to milieu and then to territory and, conversely, from rhythm to the refrain and then to music is nothing but *vibration*, resonance, the mutual condition both of material forces at their most elementary levels, and of music at its most refined and complex. ("Every milieu is vibratory" [313].) What is transmitted and transmuted throughout this vast evolution is nothing but vibration, vibrations in their specificity, vibrations as they set objects moving in their wake, as they produce harmonic and dissonant vibratory responses. Vibration is the common thread or rhythm running through the universe from its chaotic inorganic interminability to its most intimate forces of inscription on living bodies of all kinds and back again. It is vibration that constitutes the harmony of the universe with all its living components, enabling them to find a vibratory comfort level—neither too slow or too fast—not only to survive but above all to generate excess, further vibratory forces, more effects, useless effects, qualities that can't be directly capitalized. Vibration resonates through the cosmos, constituting the very possibility of

those rhythms that come to territorialize the earth and the pleasures of the living who mark it as their own.

These rhythms of the body—the rhythms of seduction, copulation, birth, death—coupled with those of the earth—seasons, tides, temperatures—are the conditions of the refrain, which encapsulates and abstracts these rhythmic or vibratory forces into a sonorous emblem, a composed rhythm. This rhythm works, has its effects, not in terms of the beauty of its composition or performance (whatever criteria might be used in their assessment) but in terms of its impact on other living forms, those most like it, its own species. Rhythms, regularized patterns of vibration or resonance, are what move from the refrain to the body. What else is both labile enough and appealing enough to slip from its material to its most immaterial effects, from the energy of the universe to the muscular oscillations that constitute pleasure and pain in living things? What else enables the body itself, the internal arrangement of its organs and their hollows, to resonate and to become instruments of sonorous expression?[32]

Vibrations are oscillations, differences, movements of back and forth, contraction and dilation: they are a becoming-temporal of spatial movements and spatial processes, the promise of a future modeled in some ways on the rhythm and regularity of the present. Vibrations are vectors of movement, radiating outward, vibrating through and around all objects or being dampened by them. Music is the result of the movements of territorialization, deterritorialization, and reterritorialization of vibratory force in its articulation of (the division or difference between) the body and the earth.

32. Arguably the first musical instrument was the hollow crest of the long extinct *Parasaurolophus,* which it used as a kind of trumpet or bodily resonator: "What makes *Parasaurolophus* interesting is that it produced not just any old sounds, but musical instruments—*tones.* Its crest was one of the first musical instruments. . . . Musical tones are formed from particular patterns of sound produced only by the vibration of certain simple shapes. Such shapes hardly ever occur naturally. Wind may occasionally whistle and brooks may sometimes babble melodiously, but nature mostly makes noise" (Jourdain 1997:31).

While music makes use of the refrain as its condition of existence, it also removes the refrain from its intimate relation to the constitution of territory: it deterritorializes the refrain. Music addresses the refrain as its condition but also as its problem (Deleuze and Guattari 1987:300), as that which presses on it and to which it must respond with invention. The history of music consists in nothing but the invention of lines of flight, forms of escape from the capture of the refrain, the extension and transformation of the refrain beyond the territory and home that it establishes into a world it no longer binds and keeps at bay. If the refrain protects us from chaos and entices us to abide and enjoy in a region provisionally enclosed from chaos, music opens up and transforms us, making of both our bodies and of the earth itself a new site of becomings toward a differently contained and directed chaos, to the opening up and exploration of chaotic elements.[33]

The refrain is fundamentally constructive: it brings together a series of disparate elements all fundamentally vibrational—sights, sounds, rhythms, material objects, geographical features, found objects, its own bodily reactions—into an organized synthetic totality, a territory that now contains or locates expressive qualities—colors, textures, tones, tempi—all made into a kind of assemblage, a natural creation. The refrain decomposes elements in order to recompose new totalities that amuse, protect, and enhance. The refrain needs to be deterritorialized, its elements transformed and reoriented away from its incantatory relation to a location and specific bodies and their sensibilities toward the cosmos itself. Music is the addition and subtraction, the resonance or dissonance of the refrain elements that are now let loose on their own musical trajectory:

33. Claire Colebrook has understood that art is the way in which life gives itself the power to intensify itself, the way in which thought "approaches infinite speed" (2006:100). "Once sensation is liberated from a produced relation, or sensation as it is lived, [in art] we reach sensation as it stands alone, the vibration or *power to differ* of life, from which relations are effected: 'sensation in itself'" (99).

the refrain is a prism, a crystal of space-time. It acts upon that which surrounds it, sound or light, extracting from it various vibrations, or decompositions, projections, or transformations. The refrain also has a catalytic function: not only to increase the speed of the exchanges and reactions in that which surrounds it, but also to assure indirect interactions between elements devoid of so-called natural affinity, and thereby to form organized masses. The refrain is therefore of the crystal or protein type. The seed, or internal structure, then has two essential aspects: augmentations and diminutions, additions and withdrawals, amplifications and eliminations by unequal value.

(DELEUZE AND GUATTARI 1987:348–349)

Music is not the conversion, translation, or restructuring of the natural, evolutionary order's refrain into human musical notation, vocalization, or instrumentation, but the rendering sonorous of forces, ultimately the forces of chaos itself, that are themselves nonsonorous. Music sounds what has not and cannot be heard otherwise. It does not utilize the bricolage technique of the refrain, whose inventiveness consists in the juxtaposition of elements that do not without external intervention belong together, but the inventiveness to follow a line (of flight), a musical theme, a polyphonous interplay of themes, a particular melody, range of tones, or tempi, as far as they will go, giving voice or sound to what has not been heard before. That is why, for Deleuze and Guattari, music is always minoritarian, a block of becoming, which is also a mode of giving voice to social minorities—a becoming-woman, a becoming-child, and a becoming-animal that cannot speak or articulate itself as such—even as it is a majoritarian or popularizing, capitalizing, and imperializing of the arts (indeed the most majoritarian and popularizing, the most capitalizable of all the art forms).[34]

34. "What does music deal with, what is the content indissociable from sound expression? It is hard to say, but it is something: *a* child dies, a child plays, a woman is born, a woman dies, a bird arrives, a bird flies off. We wish to say that these are not accidental themes in music (even if it is possible to multiply examples), much less imitative exercises: they are something essential. Why a child, a woman, a

Music is an escape from the refrain even as it draws the refrain along with itself: it is the freeing up of sonorous movements and soundless rhythmic forces from the constraints imposed on sound, vocality, vibration, resonance from codes, contents, and specific effects even as it reissues and reinstates other codes, contents, and effects that are no longer recognizable. Music thus both breaks and dislocates; it breaks down the refrain, it dislocates it from its home and from the safety zone it marks around itself.[35] Music intensifies the refrain through the creation of new forms, patterns, musical shapes, new echoes of other sounds and forms that leave behind what is recognizable to engender an unknown, a joyful (or excruciating) movement of invention. What is deterritorialized from the refrain is now reterritorialized as music, that is, not positioned in a definable geographical territory but within a plane of composition in which it summons up primordial fears, desires, and pleasures (as does the territorializing power of the refrain) only to direct them, reterritorialize them, onto the plane of music itself. The becoming-music of the refrain is also the becoming-excessive or the becoming-cosmic of sound, the freeing of sound from any origin or destination and its elaboration as pure movement—movement without subject or goal, aim or end:

> Of course, Messiaen says, music is not the privilege of human beings: the universe, the cosmos, is made of refrains; the question in music is that of a power of deterritorialization permeating nature, animals, the elements , and deserts, as much as human beings. The question is more what is not musical in human beings, and what already is musical in nature. . . . It is necessary for

bird? It is because musical expression is inseparable from a becoming-woman, a becoming-child, a becoming-animal that constitute its content. Why does the child die, or the bird fall as though pierced by an arrow? Because of the 'danger' inherent in any line that escapes, in any line of flight or creative deterritorialization: the danger of veering toward destruction, toward abolition" (Deleuze and Guattari 1987:299).

35. "Music has a thirst for destruction, every kind of destruction, extinction, breakage, dislocation. Is that not its potential 'fascism'?" (ibid., 299).

the nonmusical sound of the human being to form a block with
the becoming-music of sound, for them to confront and embrace
each other like two wrestlers who can no longer break free from
each other's grasp.

<div align="right">(DELEUZE AND GUATTARI 1987:309)</div>

THE PLANE OF COMPOSITION

Art does not need science or philosophy to function: it is a perfectly
autonomous activity. Although it borders and touches on the same
elements that concern science and philosophy—those elements that
I have called chaos, territory, and body—art does so in its own
ways, using its own techniques to develop its own objects and prac-
tices, its own binding plane of cohesion that brings it together with
all other works of art, those that predate and postdate it, those with
which it engages and others it criticizes. The work of art, whether
pictorial, tactile, or sonorous, is a block of intensities, a compound
of sensations and affects, of intensities that have gone beyond a
subject to become entities themselves.[36] But these sensations and
affects do not in themselves make up art (on the contrary, art is
composed of materials, sounds, colors, textures, melodies and not
affects or sensations). They are the products of art, what art makes,
what enables art to stand on its own, independent of its creator and
of the circumstances of its creation.

A work of art is thus not a series of sensations that depend on
either a creator (composer or performer) or an audience, but an au-
tonomous block of sensations, affects, forces, intensities that lasts

36. "Percepts are no longer perceptions; they are independent of a state of those
who experience them. Affects are no longer feelings or affections; they go beyond
the strength of those who undergo them. Sensations, percepts and affects are *be-
ings* whose validity lies in themselves and exceeds any lived. They could be said
to exist in the absence of man because man, as he is caught in stone, on the can-
vas, or by words, is himself a compound of percepts and affects. The work of art
is a being of sensation and nothing else: it exists in itself" (Deleuze and Guattari
1994:164).

eternally, preserving itself as such.[37] This is not a block of throbbing bodily sensations a subject might carry around in joy or anger, but sensation of this or that substance or material, sensation embodied as and in material forms, "the smile of oil, the gesture of fired clay, the thrust of metal" (Deleuze and Guattari 1994:166). The plane of composition draws itself toward and produces itself only through a material plane, through and as material objects, whether those of the visual or of the musical arts. Art works through and as materiality, but it is the event of sensation and its autonomous life that transforms a random material composition into a work of art, even though there can be no work of art without the particular materialities it has utilized.[38]

Can the material bear the sensation it upholds? And can the sensation stand upright, express itself, produce pure sensory qualities, through the material forms and forces it lays hold of? These are the questions to which art addresses itself, properly artistic questions. What affect is produced? And how does this affect wrench from its materiality what has not been perceived or sensed before? How does the work of art bring about sensations, not sensations of what we know and recognize, but of what is unknown, unexperienced, traces not of the past but of the future, not of the human and its recognized features, but of the inhuman?[39] Is this not the very goal

37. "In music, the minor mode is a test that is especially essential since it sets the musician the challenge of wresting it from its ephemeral combinations in order to make it solid and durable, self-preserving, even in acrobatic positions. The sound must be held no less in its extinction than in its production and development" (Deleuze and Guattari 1994:165).

38. "What is preserved by right is not the material, which constitutes only the de facto condition, but, insofar as this condition is satisfied (that is, that canvas, color, or stone does not crumble into dust), it is the percept or affect that is preserved in itself. Even if the material lasts for only a few seconds it will give sensation the power to exist and be preserved in itself *in the eternity that coexist with this short duration.* So long as the material lasts, the sensation enjoys an eternity in those very moments. Sensation is not realized in the material without the material passing completely into the sensation, in the percept or affect" (ibid., 166–167).

39. "In short, the being of sensation is not the flesh but the compound of nonhuman forces of the cosmos, of man's nonhuman becomings, and of the ambiguous

that art sets itself—the exploration of the sonorous and pictorial becomings of the universe that are always coupled together with the becoming-cosmic and becoming-other of the living subject? Art is the extraction of those qualities of materials, from the particularity of sounds and colors that enable sensations of a life to come to appear, to mark eternity, to resonate with the (inhuman, unperceived) forces of the universe itself. Art is what enables chaos to appear as sensation, as intensity, without imperiling or engulfing the subject. Art unleashes, intensifies, and celebrates precisely the creative and destructive impact of vibratory force on bodies, on collectives, on the earth itself: it protects and enhances life that is and announces life to come.

What does this have to do with science? The material plane of forces, energies, and effects that art requires in order to create monuments of sensation that are artworks are shared in common with science. Science, like art, plunges itself into the materiality of the universe, though with very different aims in mind. Where science seeks the regularities, predictabilities and consistencies—the patterns—of this chaos, art seeks its force, its impact. This is not to say that art does not draw on science or that science does not draw on art, but in drawing on the other's resources each must transform the work of the other into its own language and its own purpose. Art thus directs many of its technical questions to science; indeed it may even draw on scientific techniques and methods for its own artistic production. But this work must be situated on the artistic plane of composition. Art addresses not matter's regular features as science does, but its expressive qualities, its "aesthetic" resources, its capacity to sustain and bring forth sensations. If art frames chaos in order to extract from it the materials and energies, the territory and subjects it requires to embody sensation, then science grids chaos, placing over chaos a network of coordinates, a plane of reference, in order to extract variables, formulae, probabilities, a mode of comfort and order, a form of predictability, in the world.

———————

house that exchanges and adjusts them, makes them whirl around like winds. . . . Is this not the definition of the percept itself—to make perceptible the imperceptible forces that populate the world, affect us, and make us become?" (ibid., 181–182).

What science and art share is precisely the vibratory structure of the universe, the emanating vibratory force of chaos itself. Art makes of this vibrational force a sensation (sensation, after all is nothing but a vibratory difference capable of resonating bodily organs and the nervous system) whereas science makes of it a pattern and, eventually, measurement, ratio, or formula. Sensation contracts the vibratory waves of matter, of the earth and ultimately of chaotic cosmic forces, into sensory forms that are capable of functioning as a stimulus to the nervous system. Art transmits vibratory force through its successful transformations from energy to sensation to stimulation. Art contracts, which is to say it synthesizes and compresses the materiality that composes it, transmitting the force of materiality, its vibratory resonance, from a work to a body.[40] By contrast, science contains vibratory force within a series of representations, symbols, that transform it from quality to quantity, placing boundaries, limits, experimental conditions on those forces so that their vibratory effects become predictable, produce constants, creating invariable relations between apparently independent factors. Art unleashes and intensifies, through the principles of composition, what science contains and slows down through the plane of reference, precisely the creative and destructive impact of vibratory force on bodies, on collectives, on the earth itself. And it is only philosophy that is able to understand this common element shared by the arts and the sciences, for it is only through the mediation that philosophical concepts offers that artistic sensations and scientific theorems can interact without colonization, without the one taking over the operations of the other.

40. "Sensation is excitation itself, not insofar as it is gradually prolonged and passes into the reaction but insofar as it is preserved or preserves its vibrations. Sensation contracts the vibrations of the stimulant on a nervous surface or in a cerebral volume: what comes before has not yet disappeared when what follows appears. This is its way of responding to chaos. Sensation itself vibrates because it contracts vibrations. It preserves itself because it preserves vibrations. It is Monument. It resonates because it makes its harmonics resonate. Sensation is the contracted vibration that has become quality, variety" (ibid., 211).

3

SENSATION. THE EARTH, A PEOPLE, ART

Art reminds us of states of animal vigor; it is on the one hand
an excess and overflow of blooming physicality into the world
of images and desires; on the other, an excitation of the animal
functions through the images and desires of an intensified life—
an enhancement of the feeling of life, a stimulant to it.

—FRIEDRICH NIETZSCHE,
THE WILL TO POWER

ART AND THE ANIMAL

Art is of the animal. It comes, not from reason, recognition, in-
telligence, not from a uniquely human sensibility, or from any of
man's higher accomplishments, but from something excessive, un-
predictable, lowly. What is most artistic in us is that which is the
most bestial. Art comes from the excess, in the world, in objects,
in living things, that enables them to be more than they are, to
give more than themselves, their material properties and qualities,
their possible uses, than is self-evident. Art is the consequence of
that excess, that energy or force, that puts life at risk for the sake
of intensification, for the sake of sensation itself—not simply for
pleasure or for sexuality, as psychoanalysis suggests—but for what
can be magnified, intensified, for what is more, through which cre-
ation, risk, innovation are undertaken for their own sake, for how
and what they may intensify.

Psychoanalysis has the relations between art and sexuality at
least half-right. Art is connected to sexual energies and impulses,
to a common impulse for more. But, for Freudian psychoanaly-

sis, sexuality transforms or converts itself into art only through representation, through the transformation of an organ-oriented libido into the energy of creative material production: art is the expression of a sublimated sexual impulse, an impulse that must be renounced if it is to gain some partial satisfaction.[1] This capacity for displacement, for transferring sexual intensity or libido into desexualized or sublimated creative activities is, for Freud, a uniquely human capacity, the result of the untethering of the drive from a seasonally regulated sexuality, that is, the drive's capacity, through vicissitudes, to transform itself into something nonsexual.[2] It is only the sexual drive, not sexual instincts, that can be deflected into nonsexual aims.[3] It will my claim here that it is not exactly true that art is a consequence of the excesses that sexuality or the sexual drive poses, for it may be that sexuality itself needs to function artistically to be adequately sexual, adequately creative, that sexuality (as neither drive nor instinct but rather the alignment of bodies and practices with other bodies or with parts of one's own

1. I have outlined Freud's account of art and the special relation he posits between repressed homosexuality and creative sublimation in Grosz 2001a.

2. For Freud, sublimation is the capacity for exchanging a sexual for a desexualized aim that "consists in the sexual trend abandoning its aim of obtaining a component or a reproductive pleasure and taking on another which is related genetically to the abandoned one but is itself no longer sexual and must be described as social. We call this process 'sublimation,' in accordance with the general estimate that places social aims higher than sexual ones, which are at bottom self-interested. Sublimation is, incidentally, only a special case in which sexual trends are attached to other, non-sexual ones" (Freud 1917:345).

3. "The sexual instinct . . . is probably more strongly developed in man than in most of the higher animals; it is certainly more constant, since it has almost entirely overcome the periodicity to which it is tied in animals. It places extraordinaly large amounts of force at the disposal of civilized activity, and it does this in virtue of its especially marked characteristic of being able to displace its aim without materially diminishing in intensity. This capacity to exchange its originally sexual aim for another one, which is no longer sexual but which is psychically related to the first aim, is called the capacity for *sublimation*. In contrast to this displaceability, in which its value for civilization lies, the sexual instinct may also exhibit a particularly obstinate fixation which renders it unserviceable and which sometimes causes it to degenerate into what are described as abnormalities" (Freud 1908:187).

body) needs to harness excessiveness and invention to function at all.

There is an involuted and oblique relation between the energies of sexual selection (rather than, as for Freud, sexual satisfaction or orgasmic release), the attraction to and possible attainment of sexual (though not necessarily copulative) partners[4]—human and otherwise—and the forces and energies of artistic production and consumption. Art is of the animal to the extent that creation, the attainment of new goals not directly defined through the useful, is at its core. It will be my task to elaborate a genealogy of the visual and plastic arts that refuses to reduce art to the forces and effects of natural selection but links them instead to the excessive expenditures involved in sexual selection.

For Darwin himself, as opposed to his Spencerian and neo-Darwinian successors,[5] the living being is "artistic" to the extent that its body or products have within them something that attracts or entices not only members of the opposite sex but also members of the same sex and members of different species. For Darwin, this

4. For Darwin it is quite clear that not all members of any species need to reproduce. There is a high biological tolerance for a percentage of each group not reproducing, with no particular detriment to that group and indeed some major advantages: "Selection has been applied to the family, and not to the individual, for the sake of gaining serviceable ends. Hence we may conclude that slight modification of structure or of instinct, correlated with the sterile condition of certain members of the community, have proved advantageous: consequently the fertile males and females have flourished, and transmitted to their fertile offspring a tendency to produce sterile members with the same modification" (Darwin 1996:354). Although Darwin, of course, has no specific discussion of homosexuality, it seems clear that his discussion of sterile or noncopulative members of animal communities could provide an account of the productive rather than counterproductive role of homosexuality, which in sociobiological circles has tended to be regarded as a disadvantage unless it can be somehow tied to social altruism or the handing of genetic advantages to one's near relatives rather than one's offspring. Homosexuality is one of the many variations within species that enable them to be fit and/or attractive to others in ways that are unpredictable in advance. In other words, it is not clear that the homophobia that infects much of sociobiology can justify itself through Darwin's own writings.

5. I have in mind here the works of some of the most well-known neo-Darwinists, among them Daniel Dennett, Richard Dawkins, and E. O. Wilson.

attraction is largely but not exclusively heterosexual, usually directed to members of the opposite sex, though it invariably entails some bodily intensification or magnification of sexually specific characteristics. Sexual differences are morphological or bodily differences, differences that can be discerned and used systematically to differentiate between one type of body and another. Sexual selection magnifies and highlights these morphological differences and transformations—those differences that attract or appeal are more likely to be selected and incorporated into successive generations, which are more likely to differ further from each other—that enhance the body's sexual appeal. This calling to attention, this making of one's own body into a spectacle, this highly elaborate display of attractors, involves intensification. Not only are organs on display engorged, intensified, puffed up, but the organs that perceive them—ears, eyes, nose—are also filled with intensity, resonating with colors, sounds, smells, shapes, rhythms.[6]

This may be why Darwin claims some species of salmon, trout, perch, and stickleback change their color during the breeding season, transforming from drab to iridescent and back seasonally, de-

6. Lingis has spent considerable effort discussing the powerful effects of "organs to be looked at," which function well beyond the logic of natural selection: the most spectacular fish often live at depths where either they or their predators are blind or operate through other senses than vision. This makes it clear that there is an excess, left over from or in addition to the needs of survival, a morphological capacity for intensifying bodies and functions that does not operate only or primarily in terms of an external (predatory?) observer: "The color-blind *octopus vulgaris* controls with twenty nervous systems the two to three million chromatophores, iridophores and leucophores fitted in its skin; only fifteen of these have been correlated with camouflage or emotional states. At rest in its lair, its skin invents continuous light shows. The sparked and streaked coral fish school and scatter as a surge of life dominated by a compulsion for exhibition, spectacle, parade. . . . The most artful blended pigments the deep has to show are inside the shells of abelones [*sic*], inside the bones of parrotfish, on the backs of living cones, where the very abelones [*sic*] and parrotfish and cones themselves shall never see them. The most ornate skins are on the nudibrachia, blind sea slugs. In the marine abysses, five or six miles below the last blue rays of the light, the fish and the crabs, almost all of them blind, illuminate their lustrous colors with their own bioluminescence, for no witness" (Lingis 1984:8–9).

pending on their sex.⁷ This is not simply a functional coloring that acts as camouflage, protecting fish from predation. Konrad Lorenz has suggested that this spectacular coloring may act as a form of aggression, the vivid and unambiguous marking of territory. In other words, for Lorenz and other neo-Darwinists, this excess is not really excessive: it is the bodily expression of something like a territorial imperative, a key element in the struggle for survival, that is, in natural selection. These beautifully striking and provocative colors, shapes, organs, act, for Lorenz, as territorial posters or placards of possession, markers that function to scare rivals and defend territory. In being rendered functional, however, all excess and redundancy are eliminated; sexual selection is reduced to natural selection. Lorenz argues that the four great biological drives— hunger, sex, fear, and aggression—must each be understood in terms of natural selection alone. Like other neo-Darwinians, he reduces sexual selection to natural selection, thereby simplifying and rendering evolution monodirectional, regulated only by the selection of randomly acquired characteristics and not by the unpredictable vagaries of taste and pleasure that sexual selection entails.

7. Darwin discusses in extensive detail the transformations in coloring in various species, ranging from birds to reptiles and fish, which undergo seasonal color changes that intensify their appeal for the opposite sex. In the case of the stickleback, for example, a fish that can be described as "beautiful beyond description," Darwin quotes Warington: "The back and eyes of the female are simply brown, and the belly white. The eyes of the male, on the other hand, are "of the most splendid green, having a metallic lustre like the green feathers of some humming-birds. The throat and belly are of a bright crimson, the back of an ashy-green, and the whole fish appears as though it were somewhat translucent and glowed with an internal incandescence. And after the breeding-season these colours all change, the throat and belly become of a pale red, the back more green, and the glowing tints subside. That with fishes there exists some close relation between their colours and their sexual functions we can clearly see;—firstly, from the adult males of certain species being differently coloured from the females, and often much more brilliantly;—secondly, from these same males, whilst immature, resembling the mature females;—and lastly, from the males, even of those species which at all other times of the year are identical in colour with the females, often acquiring brilliant tints during the spawning-season" (Darwin 1981, book 2:14–15).

For Darwin himself, however, these markings, which he acknowledges may serve aggressive functions, are *not* the conditions of territoriality but the raw materials of sexual selection, excesses that are produced and explored for no reason other than their possibilities for intensification, their appeal.[8]

Many battles between rivalrous males fought apparently over territory are in fact undertaken, in Darwin's opinion, primarily to attract the attention of females who may otherwise remain indifferent to male display. In the case of battling birds, many territorial struggles are primarily theatrical, staged, a performance of the body at its most splendid and appealing, rather than a real battle with its attendant risks and dangers: in the case of the *Tetrao umbellus,* more commonly known as the ruffed grouse, the battles between males "are all a sham, performed to show themselves to the greatest advantage before the admiring females who assemble around; for I have never been able to find a maimed hero, and seldom more than a broken feather" (1981, book 2:50). Ornamental display occurs in the most successful and aggressive males, yet even those males who are most successful at fending off predators and rivals are not always guaranteed to attract the attention of a possible partner. It is not clear that the skills the male displays are those that attract females, even if they are successful in various battling spectacles.

Although beauty of all kinds is displayed, this beauty puts the creature in some kind of potential danger, it has a cost, even if it is not the cost of real battle but of becoming more visible or audible, more noticeable to predators as well as suitors: "Even well-armed males, who, it might have been thought, would have altogether depended for success on the law of battle, are in most cases highly

8. Darwin argues that although it is possible that the brilliant coloring of fish may serve to protect them from predators, as Lorenz (and Huxley) claim, it is more likely that it makes them more vulnerable to predators, which tends to affirm their function as sexual lures more than as aggressive placards or banners: "It is possible that certain fishes may have been rendered conspicuous in order to warn birds and beasts of prey (as explained when treating of caterpillars) that they were unpalatable; but it is not, I believe, known that any fish, at least any fresh-water fish, is rejected from being distasteful to fish-devouring animals" (Darwin 1981, book 2:17–18).

ornamented; and their ornaments have been acquired at the expense of some loss of power. In other cases, ornaments have been acquired at the cost of increased risk from birds and beasts of prey" (Darwin 1981, book 2:123). Nor can the defense of territory be identified with sexual success, which operates according to different criteria. Sexual selection, as Darwin has made clear, imperils as much—and perhaps to the same degrees—as it attracts. As we shall see, however, territoriality is indeed bound up with the production of intensities, that is, with sexual and artistic production, the creation of rhythmical or vibrational qualities, but not as precondition; rather, territory functions as an effect of erotic intensification.[9] Territory is produced, made possible, when something, some property or quality, can be detached from its place within a regime of natural selection and made to have a life of its own, to resonate, just for itself. Territory is artistic, the consequence of love not war, of seduction not defense, of sexual selection not natural selection.

Are animals artistic? Certainly, if by that we understand that they intensify sensation (including the sensations of their human observ-

9. As Deleuze and Guattari suggest, it is not the mark that is formed to protect a preexisting territory, as Lorenz implies, but rather it is the mark that creates territory, for territory itself presumes art! "[In Lorenz's account] a territorial animal would direct its aggression, starting at the point where that instinct became intraspecific, was turned against the animal's own kind. A territorial animal would direct its aggressiveness against members of its own species; the species would gain the selective advantage of distributing its members throughout a space where each would have its own place. This ambiguous thesis, which has dangerous political overtones, seems to us to have little foundation. It is obvious that the function of aggression changes when it becomes intraspecific. But this reorganization of the function, rather than explaining territory, presuppose it. There are numerous reorganizations within the territory, which also affects sexuality, hunting , etc. . . . The T factor, the territorializing factor, must be sought elsewhere; precisely in the becoming-expressive of rhythm or melody, in other words, in the emergence of proper qualities (color, odor, sound, silhouette . . .). Can this becoming, this emergence, be called Art? That would make territory a result of art. The artist: the first person to set out a boundary stone, or to make a mark. Property, collective or individual, is derived from that, even when it is in the service of war and oppression. Property is fundamentally artistic because art is fundamentally *poster, placard*" (Deleuze and Guattari 1987:316).

ers), that they enjoy this intensification, and that it entails a provisional stability such as the constitution of a territory implies. This animal-intensification is artistic even if it is not yet composed, not yet art (it is refrainlike): and, further, it provides the marks, the emblems, the very qualities by which a composed art becomes possible. Art is of the animal precisely to the degree that sexuality is artistic.

SENSATION AND THE PLANE OF COMPOSITION

Painting raises a series of questions that are unique, specific to its own history and materials. Like each of the arts, painting addresses problems about the relations between the body and the earth, between corporeal and terrestrial forces, but each does so in its own way, with its own materials, its own techniques, forms, and qualities, and each does so in light of the contributions of all the earlier forms of that art (and of all other arts). This field, the condition of actuality for the production and reception of artwork, we might understand, following Deleuze and Guattari, as the plane of composition. The plane of composition is the field, the plane, of all artworks, all genres, all types of art, the totality of all the various forms of artistic production in no particular order or organization, that which is indirectly addressed and transformed through each work of art.

Deleuze and Guattari affirm the plane of composition as the collective condition of art making: it contains all works of art, not specifically historically laid out, but all the events in the history of art, all the transformations, "styles," norms, ideals, techniques, and upheavals, insofar as they influence and express each other. The plane of composition is not a literal plane (otherwise it itself would have to be composed) but a decentered spatiotemporal "organization," a loose network of works, techniques, and qualities, within which all particular works of art must be located in order for them to constitute art. These works do not require recognition as such; they do not require any form of judgment to assess their quality or relative value: they simply need to exist as art objects. It is this common location, the common (yet incorporeal) context all art-

works share, that enables art to be assessed in whatever ways it is and allows art objects to refer to, incorporate, digest, contest, and transform each other. There is no common quality artworks must have, not even within any particular art form: but the capacity that all artworks have to be located within a milieu of other artworks— even as upheaval and innovation—means that they are constituted not through intentionality but through the work itself, through its capacity to be connected to, or severed from, other works.

All works of art share something in common, whatever else may distinguish different forms, genres, and techniques from each other: they are all composed of blocks materiality becoming-sensation.[10] Art is what intensifies, produces sensations, and uses them to intensify bodies. Whatever materials compose them, works of art monumentalize neither events nor persons, materials nor forms, only sensations: "The work of art is a being of sensation and nothing else" (1994:164). Does this mean that works of art exist only to the extent that they are sensed, perceived? Are such works reliant on external observers to sense them? Not at all: the sensations produced are not the sensations of a subject, but sensation in itself, sensation as eternal, as monument. Sensation is that which is transmitted from the force of an event to the nervous system of a living being and from the actions of this being back onto the world itself.

Deleuze draws on and transforms the writings of Erwin Straus and Henri Maldiney regarding the role of sensation in the visual arts. Although Straus, for example, develops a largely phenomenological understanding of sensation—sensation as that which the sensing subject shares in common with a sensed object, sensation as a two-sided phenomenon in which one side faces the world of objects and the other side faces the world of lived experience. Straus's argument, in brief, is that the primary world given by the senses is what preexists the formation of the subject and its sharp separation from the object and what the subject shares in common with animal life, a being-with-the-world in which sensation is aligned with the body's capacity for movement.

10. Colebrook provides an illuminating analysis of the status of sensation in Deleuze's work (2006:94ff).

Before space and time are oriented by coordinates, abstract positions, measurements, they coexist with and are defined by the body's here and now. Sensation thus includes not only the perceiving body but also the Umwelt in which the body moves through an ever changing horizon. Sensation is neither in the world nor in the subject but is the relation of unfolding of the one for the other through a body created at their interface (see Straus 202). Perception is thus, for Straus (as for Bergson), linked to the establishment of coordinates and abstract regularities, while sensation is that which cannot be mapped or completed, always in the process of becoming something else.

Straus illustrates the distinction between perception and sensation in terms of the opposition between geography and landscape. Geography is the space of the map, that which is regulated by measurable abstract coordinates, what Deleuze and Guattari refer to as striated or sedentary space, a space whose location or region is abstracted from its lived qualities.[11] Landscape, by contrast is that space revealed by sensation, which has no fixed coordinates but transforms and moves as a body passes through it. Landscape art has, for Straus, the peculiar possibility of making visible that which sensation senses of the invisible: "Landscape painting does not depict what we see, i.e., what we notice when looking at a place, but—the paradox is unavoidable—it makes visible the invisible, although it be something far removed. Great landscapes all have a visionary character. Such vision is of the invisible becoming visible" (Straus 322).

Deleuze rapidly "materializes" Straus's concept. He differs from Straus's more directly phenomenological reading by insisting that the subject side or face of sensation cannot be identified with the phenomenological subject of lived experience, but must be understood in terms of the neurological and physiological subject of action and passion, and the object side or face is not a pure thing-in-itself but a complex event with its own forms of singularity or individuality, however impersonal. Sensation is that which is transmitted from the

11. See plateau 14, "1440: The Smooth and the Striated" (Deleuze and Guattari 1987).

force of an event to the nervous system of a living being and from the actions of this being back onto events.[12]

Sensation is the zone of indeterminacy between subject and object, the bloc that erupts from the encounter of the one with the other. Sensation impacts the body, not through the brain, not through representations, signs, images, or fantasies, but directly, on the body's own internal forces, on cells, organs, the nervous system. Sensation requires no mediation or translation. It is not representation, sign, symbol, but force, energy, rhythm, resonance.[13] Sensation lives, not in the body of perceivers, subjects, but in the body of the artwork. Art is how the body senses most directly, with, ironically, the least representational mediation, for art is of the body, for it is only art that draws the body into sensations never experienced before, perhaps not capable of being experienced in any other way, the sunflower-sensations that only Van Gogh's work conjures, the "appleyness of the apple" in Cézanne,[14] the "Rembrandt-universe" (177) of affects or the meat-sensations that underlies flesh in Bacon. Sensation draws us, living beings of all kinds, into the artwork in a strange becoming in which the living being empties itself of its interior to be filled with the sensation of that work alone.

Just as we perceive objects where they are, in space, and we re-

12. "Sensation is the opposite of the facile and the ready-made, the cliché, but also of the 'sensational,' the spontaneous, etc. Sensation has one face turned toward the subject (the nervous system, vital movement, 'instinct,' 'temperament'—a whole vocabulary common to both Naturalism and Cézanne), and one face turned toward the object (the 'fact,' the place, the event). Or rather, it has no faces at all, it is both things indissolubly, it is Being-in-the-world as the phenomenologists say: at one and the same time I *become* in the sensation and something *happens* through the sensation, one through the other, one in the other. And at the limit, it is the same body that, being both subject and object, gives and receives the sensation. As a spectator, I experience the sensation only by entering the painting, by reaching the unity of the sensing and the sensed" (Deleuze 2003:31).

13. Simon O'Sullivan's recent (2006) text insists on the anti and nonrepresentational status of Deleuze and Guattari's understanding of the arts, an emphasis that seems to me perfectly appropriate in understanding their unique contributions to art history and interpretation.

14. In D. H. Lawrence's words, quoted in Deleuze 2003:23.

member events where they are, in the past, that is, just as space and time are not *in* us, as Bergson reminds us,[15] so sensation is not in us either. We are in it whenever we sense, and it brings us to where sensation occurs, in the artwork itself. Sensation draws us, living beings of all kinds, into the artwork in a strange becoming in which the living being empties itself of its interior to be filled with the sensation of that work alone: "Color is in the body, sensation is what is painted. What is painted on the canvas is the body, not insofar as it is represented as an object, but insofar as it is experienced as sustaining *this* sensation" (Deleuze 2003:32).

The artwork is a compound of sensation. It is not a single or found sensation (even if the object is a ready-made, as in Duchamp), for then it would remain what it is, a changing, transforming, useful, or insignificant object. The artwork is a compound of sensations, composed sensations, sensations composed through materials in their particularity. Sensations are not colored, shaped, formed in the artwork, but through the artwork are coloring, shaping, and forming forces (of both subject and object). The artwork arrests, freezes forever, a look, a moment, a gesture, an activity, from the transitory and ever different chaos of temporal change, in the transitions between one percept and affect and the next that marks the life of a living being. Art arrests this endless becoming into a becoming of its own: the art object now becomes sensation, not eternal in the sense that the sensation is continually experienced in one and the same way through the passage of time, but in the sense that sensation is now forever tied to this smile, this yellow, this flower in its absolute singularity. Only at the point at which material becomes expressive, takes on a life of sensation as well as its own qualities, can art begin.

Sensation can only emit its effects to the extent that its materials, materiality itself, become expressive, passing into sensation, transforming themselves, giving themselves a new quality. This is not a signifying relation, in which the material plane is understood as a chain of signifiers and the aesthetic plane is the field of the signi-

15. In Bergson, *Matter and Memory* (1988:57).

fied: rather, it is a relation of eruption or emergence. There can be no art without the materials of art, but the artistic is an eruption, a leap out of materiality, the kick of virtuality now put into and extracted from matter to make it function unpredictably. Sensations, artworks, do not signify or represent ("no art and no sensation have ever been representational"; 1994:193): they assemble, they make, they do, they produce.

Art is the becoming-sensation of materiality, the transformation of matter into sensation, the becoming-more of the artistic subjects and objects that is bound up with the subject's cross-fertilization with the art object. Art is that which brings sensations into being when before it there are only subjects, objects, and the relations of immersion that bind the one to the other. Art allows the difference, the incommensurability of subject and object to be celebrated, opened up, elaborated. The arts, each in its own way, are not just the construction of pure and simple sensations but the synthesis of other, prior sensations into new ones, the coagulation, recirculation, and transformation of other sensations summoned up from the plane of composition—indeed becoming itself may be understood as the coming together of at least two sensations, the movement of transformation that each elicits in the other.[16] Art is this processes of compounding or composing, not a pure creation from nothing, but the act of extracting from the materiality of forces, sensations, or powers of affecting life, that is, becomings, that have not existed before and may summon up and generate future sensations, new becomings.

BECOMING-OTHER

Sensations are always composite, which is also to say that they are composed. They are primarily made up of percepts and affects, ex-

16. "It is the nature of sensation to envelop a constitutive difference of level, a plurality of constituting domains. Every sensation . . . is already an 'accumulated' or 'coagulated' sensation, as in a limestone figure. Hence the irreducibly synthetic character of sensation" (Deleuze 2003:33).

tracted from the energetic forces generated between subjects and objects that are arrested, as it were, in flight, where they live as pure movement or transition. Sensations are mobile and mobilizing forces, not quite subjective or experiential (this is Deleuze's disagreement with phenomenology) and yet not fully objective or measurable in a way that material objects are. Sensations are subjective objectivities or equally objective subjectivities, midway between subjects and objects, the point at which the one can convert into the other. This is why art, the composition of material elements that are always more than material, is the major—perhaps the only—way in which living beings deal with and enjoy the intensities that are not contained within but are extracted from the natural world, chaos. Art is where intensity is most at home, where matter is most attenuated without being nullified: perhaps we can understand matter in art as matter at its most dilated, matter as it most closely approximates mind, diastole, or proliferation rather than systole and compression and where becoming is most directly in force. Art is where life most readily transforms itself, the zone of indetermination through which all becomings must pass. In this sense art is not the antithesis of politics, but politics continued by other means.[17]

Sensation has two dimensions, two types of energy: it is composed of affects and percepts. Sensation aims to extract affects from affections and percepts from perception, which is to say that it disembodies and desubjectifies affection and perception.[18] Just as sensation exists in a kind of eternity that is distinct from the finitude of its materiality, an incorporeal event on the surface of things, so

17. Deleuze suggests as much in his provocative and rather strange discussion of the work of Gérard Fromanger, that art is politics with affirmation and joy: "It [Fromanger's art] is strange, the way a revolutionary acts because of what he loves in the very world he wishes to destroy. There are no revolutionaries but the joyful, and no politically and aesthetically revolutionary painting without delight" (Deleuze, in Deleuze and Foucault 1999:76–77).

18. "The aim of art is to wrest the percept from perceptions of objects and the states of a perceiving subject, to wrest the affect from affections as the transition from one state to another: to extract a bloc of sensations, a pure being of sensations" (Deleuze and Guattari 1994:167).

sensation exists independent of the perceptions and affections that mark a living being's relations with its objects or its Umwelt. Sensation, like the plane of composition itself, is an incorporeal threshold of emergence,[19] an unpredictable and uncontainable overspilling of forces that exist hitherto only beyond and before the plane of composition, on its other side, that of chaos. In this sense art is the way in which shreds of chaos can return in sensation: it is how art returns us to the unlivable from which we came and gives us a premonition of the unlivable power to come. Percepts and affects are the inhuman forces from which the human borrows that may serve in its self-transformation and overcoming. Percepts and affects summon up a "people to come," not a public, an audience,[20] but something inhuman.

Affects are the ways in which the human overcomes itself: they are the "non-human becomings of man," the virtual conditions by which man surpasses himself and celebrates this surpassing (as only the overman can, with only joyful affects) by making himself a work of art, by his own self-conversion into a being of sensation. Affects are man's becoming-other, the creation of zones of proximity between the human and those animal and microscopic/cosmic becomings the human can pass through.[21] Affects signal that border between the human and the animal from which it has come.

19. See Deleuze 1990:6–8 for a further discussion of the event as an incorporeal that is located at the surface of states of affairs.

20. As Rajchman makes clear: "As a presupposition of a 'becoming-art,' that is not yet there is not to be confused with 'the public'—on the contrary, it helps show why art (and thought) is never a matter of 'communication,' why for [Deleuze and Guattari] there is always too much 'communication'" (2000:122). Colebrook (2006:94) makes a similar point: "Percepts and affects are *not* continuous with life and are not effects of a synthetic activity of consciousness. Affects and percepts stand alone and bear an autonomy that undoes any supposed independence of a self-constituting consciousness." See also O'Sullivan: "Art is ontologically difficult. It is not made for an already constituted audience but in fact calls its audience into being" (2006:68).

21. "Becoming is the extreme contiguity within a coupling of two sensations without resemblance or, on the contrary, in the distance of a light that captures both of them in a single reflection" (Deleuze and Guattari 1994:173).

If affects characterize a subject's relation to nonhuman becomings, percepts, those "nonhuman landscapes of nature," (1994:169) are the transformation of the evolutionary relations of perception that have attuned the living creature to its world through natural selection (as Bergson has shown)[22] into the resources for something else, something more, for invention, experiment, or art. Perceptions and affections, forces lived in everyday life, can only be wrenched from this (evolutionary) context to the extent that the natural and the lived are themselves transformed, the virtual in them explored, and strange connections—connections that have no clear point or value—elaborated with considerable effort and risk to the normalized narratives of the everyday and the assimilable. The materials of perception—the bodily relations between states of things and subjects—become the resources of the unlivable percept; the materials of affection—our sufferings, joys, horrors, our becomings, the events we undertake—become the expressions of our possibilities for inhuman transformations. Perceptions become enshrouded with affect: popes, or disembodied mouths come to embody the scream in Bacon's works, Van Gogh's head becomes captured in a web of becoming-sunflower. And affections are embedded in percepts, as in Cézanne's mountains and landscapes or Georgia O'Keefe's Southwest.

Art is not a self-contained activity in the sense that it is disconnected from the ways in which the natural and social worlds function. Art, however, is not a window onto these worlds, nor a mode of their representation or exploration: it does not take the place of social or political analysis or philosophical speculation. Rather, it is where intensities proliferate, where forces are expressed for their own sake, where sensation lives and experiments, where the

22. In his discussion of perception, on which Deleuze relies, Bergson sees perception as the honing of a synthetic, skeletalizing ability: perception is what schematizes and simplifies nature so that the living being can function there with what is perceptually predictable through its regulation by habit. Perception attunes the being to its world, and the relevant objects in that world to the living being—a mode of accommodation. See Bergson 1988:93–94.

future is affectively and perceptually anticipated. Art is where prop-
erties and qualities—sounds, rhythms, harmonies in music, colors,
forms, relations of surface and depth or visibility and invisibility
in painting, planes, volumes, surfaces, and voids in sculpture and
architecture and so on—take on the task of representing the future,
of preceding and summoning up sensations to come, a people to
come, worlds or universes to come. Art is intensely political not in
the sense that it is a collective or community activity (which it may
be but usually is not) but in the sense that it elaborates the possibili-
ties of new, more, different sensations than those we know. Art is
where the becomings of the earth couple with the becomings of life
to produce intensities and sensations that in themselves summon
up a new kind of life:

> This is, precisely, the task of all art and, from colors and sounds,
> both music and painting similarly extract new harmonies, new
> plastic or melodic landscapes, and new rhythmic characters that
> raise them to the height of the earth's song and the cry of hu-
> manity: that which constitutes the tone, the health, becoming, a
> visual and sonorous bloc. A monument does not commemorate
> or celebrate something that happened but confides to the ear of
> the future the persistent sensations that embody the event.
>
> (1994:176)

Sensation sets out not only the possible becomings of a subject-
in-process but also the possible becomings of peoples and universes
to come. It is the possibility (as opposed to virtuality)[23] of the cre-
ation of new worlds and new peoples to live and experience them.
Artworks are not so much to be read, interpreted, deciphered as
responded to, touched, engaged, intensified. Artworks don't signify
(or, if they signify, they signify only themselves); instead, they make
sensation real: "The monument does not actualize the virtual event

23. "The universes [to come] are neither virtual nor actual; they are possibles,
the possible as aesthetic category . . . the existence of the possible, whereas events
are the reality of the virtual" (Deleuze and Guattari 1994:177).

but incorporates or embodies it: it gives it a body, a life, a universe" (1994:177).

What gives sensation this power or force of directly affecting bodies? Deleuze suggests that sensation is not irreducible, a pure given, but is itself the consequence of a particular capacity sensation has to contract vibration. Sensation is excitation, extracted from objects but animated by quality, intensity only to the extent that it is transmitted to and consequently directly affects life. Sensation is vibratory excitation that preserves itself and the vibratory force of its materials to the extent it continues to generate corporeal effects, that is, continuing shocks to the nervous system.²⁴ Sensation contracts what composes it, vibrations that are colors, forms, planes, and voids, so that they become expressed and affective, so that they signal a world to come in the present and impact that world as much as possible on the presently living nervous system.²⁵ Unlike politics, sensation does not promise or enact a future different than the present, it en-forces, impacts, a premonition of what might be directly on the body's nerves, organs, muscles. The body is opened up now to other forces and becomings that it might also affirm in and as the future.

Sensation, as the contraction of vibrations, is that which mediates between the forces of the cosmos—unknowable and uncontainable forces that we experience as chaos—and the (virtual) forces of bodies, including their potential to be otherwise. Sensation fills the living body with the resonance of (part of) the universe itself, a vibratory wave that opens up the body to these unrepresented and unknowable forces, the forces of becoming-other. The body does

24. Deleuze says it explicitly: "Sensation is vibration" (2003:39).

25. "Sensation is excitation itself, not insofar as it is gradually prolonged and passes into the reaction but insofar as it is preserved or preserves its vibrations. Sensation contracts the vibrations of the stimulant on a nervous surface or in a cerebral volume: what comes before has not yet disappeared but when what follows appears. This is its way of responding to chaos. Sensation itself vibrates because it contracts vibrations. It preserves itself because it preserves vibrations: it is Monument. It resonates because it makes its harmonics resonate. Sensation is the contracted vibration that has become quality, variety" (Deleuze and Guattari 1994:211).

not contain these forces but rather is touched by them and opened up to some of the possibilities of being otherwise, which the universe contains through them.[26]

PAINTING SENSATIONS

Painting aims to visualize invisible forces, as music aims to sound forces that otherwise would remain inaudible. Each art aims to represent what is unrepresentable, to conjure up in words, paint, stone, steel, and melody, invisible and soundless forces, what is incapable of being represented otherwise or what, if represented otherwise, would bring into existence a different kind of sensation. Each of the arts, as highly particular in historical and regional specificity as it might be, aims to capture something equally accessible to all the other arts, a kind of foundation or unity, the unity in difference of the universe itself, of materiality, and of universal forces that impinge on all forms of life, each affected in their different ways. This is why each of the arts brings with it fragments and residues of all the others. When Bacon wrenches a scream from the screaming popes, he brings with it not only all the visible forces that a scream enacts, not just the force and intensity of prior pope representations, but the scream-sensation in all its multisensory richness. When he has managed to "paint the scream more than the horror" (Bacon quoted in Deleuze 2003: 34), the scream only functions as sensation to the extent that we can feel and hear it, that it vibrates as a scream, that is, as visual, it nevertheless functions as an auditory cry, resonating or vibrating through us as a scream.

26. "Sensation is excitation itself, not insofar as it is gradually prolonged and passes into the reaction but insofar as it is preserved or preserves its vibrations. Sensation contracts the vibrations of the stimulant on a nervous surface or in a cerebral volume: what comes before has not yet disappeared when what follows appears. This is its way of responding to chaos. Sensation itself vibrates because it contracts vibrations. It preserves itself because it preserves vibrations: it is Monument. It resonates because it makes its harmonics resonate. Sensation is the contracted vibration that has become quality, variety" (ibid., 211)

Painting aims to make every sense function through the eye, as music makes all sensation and the whole body, compress itself into an ear. But, equally, painting aims to enable us to see sound, as music aims to make us hear colors, shapes, forms. Each of the arts is concerned with a transmutation of bodily organs as much as it is with the creation of new objects, new forms: each art resonates through the whole of the sensing body, capturing elements in a co-composition that carries within the vibrations and resonances, the underlying rhythms, of the other arts and the residual effects of each of the senses. Painting makes the eye mobile, it places it throughout the body, it renders the visible tangible and audible as well as visible.[27]

Sensation can only be generated to the extent that each art brings into being something that the other arts could also access, each in its own way, something they all share, the forces that make each possible and connect each to both the (invisible, inaudible, intangible) forces of the universe and the sensitive mass of nerves and organs that make up a living body. It is because each of the senses—for each art orients itself to the intensification of at least one of the senses (there are, after all, arts for all the body's perceptual organs)—lays claim to forces of the universe that all the others are drawn to as well.[28]

Deleuze suggests that this is because there is indeed a common

27. "Painting . . . invests the eye through color and line. But it *does not treat the eye as a fixed organ.* . . . Painting gives us eyes all over: in the ear, in the stomach, in the lungs (the painting breathes . . .). This is the double definition of painting: subjectively, it invests the eye, which ceases to be organic in order to become a polyvalent and transitory organ objectively, it brings before us the reality of a body, of lines and colors freed from the organic representation. And each is produced by the other: the pure presence of the body comes visible as the same time that the eye becomes the destined organ of this presence" (Deleuze 2003:45).

28. "Between a color, a taste, a touch, a smell, a noise, a weight, there would be an existential communication that would constitute the 'pathic' (non-representational) moment of *the* sensation. In Bacon's bullfights, for example, we hear the noise of the beast's hooves; . . . and each time meat is represented, we touch it, smell it, eat it, weigh it, as in Soutine's work. . . . The painter would thus *make visible* a kind of original unity of the senses, and would make a multisensible Figure finally appear" (ibid., 37).

force shared by all the arts and the living bodies that generate sensations out of material forms that derives from the universe itself. This is a precisely vibratory force—perhaps the vibratory structure of subatomic particles themselves?—that constructs sensations as neural reactions to inhuman forces. Perhaps it is the consequence of vibration and its resonating effects that generates a universe in which living beings are impelled to become, to change from within, to seek sensations, affects, and percepts that intensify and extend them to further transformations. And perhaps such resonance creates the very means by which the arts undertake their compositional activity: to create rhythm, the ordering and structuring of resonance, the meeting of different vibratory forces.[29]

As "more profound" than vision or hearing, rhythm (which we must understand, along with vibration, as another name for difference) is what runs from objects to organs, from organs to the objects that captivate them, and from their relations to the art objects that carry sensations. It is rhythm that is transmitted directly from universe to artwork to body and back; it is rhythm that intensifies and complicates itself the more it circulates. Deleuze is influenced by the writings of Maldiney, who, following on from, elaborating, and modifying Straus and Merleau-Ponty, understands sensation, and indeed the appearance of the artwork, as a kind of autopoesis, the eruption of self-sustaining form (1973:155–157). Rhythm is that which inheres in and generates, without ever ending or resolving this form-generation: "This sense of form in formation, in perpetual transformation in the return of the same, is properly the sense of rhythm" (1973:157).

29. "[The porousness of the arts to each other] is possible only if the sensation of a particular domain (here, the visual sensation) is in direct contact with a vital power that exceeds every domain and traverses them all. This power is Rhythm, which is more profound than vision, hearing, etc. Rhythm appears as music when it invests the auditory level, and as painting when it invests the visual level. This is a 'logic of the senses,' as Cézanne said, which is neither rational nor cerebral. What is ultimate is thus the relation between sensation and rhythm, which places in each sensation the levels and domains through which it passes. This rhythm runs though a painting just as it runs through a piece of music" (ibid., 37).

For Maldiney, form is always in the process of becoming and never given or finalized. It is generated or generates itself through a three-fold movement that Deleuze also utilizes to explain his own conception of sensation. First, there is the existential disclosure, an animal-disclosure, of the chaos of being for the living entity, the perpetual becoming of a world life does not control but that it must occupy and live through without being able to adequately position itself, the whirling chaos of sensations that are as yet unstructured and unformed, life resources and what life finds potentially excessive, overwhelming, breathtaking. Cézanne refers to this as an "iridescent chaos," an "abyss" or "catastrophe," an opening up to as well as a kind of merger with the landscape he contemplates as he prepares to paint (Maldiney 150; Deleuze 2003:83). It is a kind of collapse of visual coordinates, of orientation, of the separate positioning of the subject at a distance from the object. The second movement is a systolic compression or dilation of chaotic forces now condensed into forms, shapes, patterns, the extraction of rhythm from buzzing vibration, and a growingly discernible subject and object. For Cézanne, this is the moment at which a "stubborn geometry," "geological strata," appear as separate from the subject, as weighty objects to be observed (Maldiney 150). In the third movement there is a diastolic expansion that transforms and dissolves these forms and entities, blurring them back into the resonances of sensation. For Cézanne, this is when "an aerial, colored logic suddenly replaces the stubborn geometry. The geological strata, the preparatory labor, the moment of design collapse, crumble as in a catastrophe" (Maldiney: 185). The relation between systole and diastole is precisely definable in terms of rhythm, not as measurable or mathematically definable external and finalized form but as duration, uncountable, always in process, open-ended. Rhythm is the force of differentiation of the different calibers of vibration that constitute chaos, the body and sensation, and their interlinkage.

Maldiney's representation of the growing immersion and deformations of art refers as readily to Bacon's work as it does to Cézanne's. For Deleuze, Bacon's greatness lies in his ability to capture, as no one else has, three sorts of forces: the systolic forces of

isolation (those forces Bacon makes visible in his washed-out fields of color, in the ways in which these fields or platforms, geometrical figures isolate and bound a figure); the diastolic forces of deformation (those forces that press the body to earth, to crumple or slide over itself, where the body is in the process of becoming something else, a bird-umbrella, a piece of meat); and the forces of dissipation (those forces in which the figure fades to leave only the smile, only the scream), all of them invisible forces that separate, press down on, and fade back into the abyss or chaos from which they were extracted. Art here is the production of meat-sensations as the expression of forces of isolation, deformation, and dissipation.

This movement is nothing other than the movement of intuition, so elaborated by Bergson, in which a philosophical subject must place him or herself in the midst of things in the world without preconceived patterns or expectations and, through this immersion, to discern, gradually and with effort, through learning, the natural articulations between things, the places in things and events where differences most directly emerge.[30] From such a discernment, in separating those things that are qualitatively different from each other from those that are linked, the philosophical subject comes to learn that these differences in kind are in fact versions of differences of degree and find their place in a universe that can be understood as open-ended whole.[31] This too is a tripartite movement from chaos to the infinite through the immersion of life in the absolutely particular or the singular. Intuition is the way, for Bergson, that

30. See, in particular, *The Creative Mind* (Bergson 1946).
31. "Instead of a discontinuity of moments replacing one another in an infinitely divided time, [knowledge] will perceive the continuous fluidity of real time which flows along, indivisible. Instead of surface states covering successively some neutral stuff and maintaining with it a mysterious relationship of phenomenon to substance, it will seize upon one identical change which keeps ever lengthening as in a melody where everything is becoming, being itself substantial, has no need of support. No more inert states, no more dead things; nothing but the mobility of which the stability of life is made. A vision of this kind, where reality appears as continuous and indivisible, is on the road which leads to philosophical intuition" ("Philosophical Intuition," Bergson 1946:150–151).

the new is capable of being understood outside of or beyond ready-made concepts, opinions, or what Deleuze reviles as the cliché.[32] Perhaps Bergson's discerning subject finds its culmination, not in the theoretical speculations of the philosopher, whose orientation tends to the abstract, but in the work of the artist, writer, or musician, whose field of creation is primarily durational.

The common ground for all the arts is the rhythmic, irreducibly durational universe of invisible, inaudible forces whose order isn't experientially discernible and is thus experienced or lived, at best, as chaotic. These inartistic chaotic forces, forces that do not reveal themselves to lived bodies except through processes of composition that lay them out for visual or auditory consumption, *cannot* be lived: they are fundamentally inhuman. Sensation lives a nonorganic life, the life of an "unlivable power." We cannot live these forces, although they act through and on us; what we can do is extract something of these forces, nothing that resembles them, for they cannot present themselves, but something that partakes of them. Bacon extracts a kind of gravitational force, the force that, in the long run, convulses and contorts bodies, not through torture but through everyday positions that have collapsed upon themselves, until flesh descends from bone into meat. Bacon generates meat-sensations from capturing the force of an invisible, unheard gravitational pull. The arts each address themselves to how to present these elementary forces, forces that impinge on us as living beings, forces like "pressure, inertia, weight, attraction, gravitation, germination" (2003:48).

If there is a common "foundation" or a unity of forces that all the arts share with each other (along with science and philosophy, which are equally oriented, in very different ways, to the ordering of chaotic forces), this is not in the unity of what has been, but only in the unity of a common future: the "power of the future" is that most urgent of forces and the most imponderable. At bottom, Deleuze suggests, it may be that what all the arts share is the aim of capturing the *force of time,* of opening up sensation to the force of

32. Deleuze has the same disdain for opinion, doxa, "good sense," and other self-satisfied solutions to the problems life poses as early as *The Logic of Sense.*

the future, of making time able to be sensed not in order to control or understand duration (which cannot be controlled and is that which ensures that the self-identical is always transitional, always other, never actual) but to live it as one can, even if that means becoming-different: "To render Time sensible is itself the task common to the painter, the musician, and sometimes the writer. It is a task beyond all measure or cadence" (2003:54).[33] It is this goal that makes art itself eternal, always seeking a way to render time sensational, to make time resonate sensibly, for no art can freeze time or transform its forces except through the invention of new techniques, new forces and energies.

PAINTING TODAY

Modern painting, the art of the twentieth century and beyond, can, for the sake of argument, be divided into three broad lines that distinguish themselves in the ways in which they regulate relations between sensation and chaos. Each is a response to the end of figuration and the crisis of realism and representation posed by the advent of photography as an art form in the nineteenth century. The first is through abstraction, along the lines of the Russian constructivists from Malevich to the works of Mondrian, Klee, Kandinsky, and others. Here, for Deleuze, chaos remains the source for art, but chaos is narrowly and carefully codified, often through a mystical code, to produce an optical geometry, an artistic Platonism where art takes on the function of a kind of spiritual salvation.[34]

The second line is abstract expressionism, as perhaps initiated by

33. "When the visual sensation confronts the invisible force that conditions it, it releases a force that is capable of vanquishing the invisible force, or even befriending it [at least in the case of Francis Bacon]. Life screams *at* death, but death is no longer this all-too-visible thing that makes us faint; it is this invisible force that life detects, flushes out, and makes visible through the scream" (ibid., 52).

34. "[Abstraction] . . . offers us an asceticism, a spiritual salvation. Through an intense spiritual effort, it raises itself above the figurative givens, but it also turns chaos into a simple stream we must cross in order to discover the abstract and signifying Forms" (ibid., 84).

the whirling indeterminate forms of Turner, but represented most clearly by Jackson Pollock and action painting. Here, instead of being directed through codification, chaos is "deployed to a maximum" (2003:68), spread throughout the work itself, cramming every inch of the painted field. Painting comes as close as it possibly can to falling into chaos. Instead of the optical or geological frame, the tactile, the haptic dominates. The pattern is no longer discernible, all standard frames of reference (top/bottom, figure/ground) are subverted. Thus the eye is confused, for it functions at the mercy of the chaotic or random movements of the hand (and the body as a whole).[35]

Thus far we have either a kind of code-painting or a kind of catastrophe-painting. The third line, which lies midway between figurative art and abstractionism, Deleuze describes, following Lyotard (1971), as figural. Here Deleuze includes works (for example, those of Cézanne, Bacon, and Soutine) that rely on the visceral force of painting (unlike abstraction) yet aim to contain it to a part but not the whole of the painted field (unlike expressionism). The figural is, for Deleuze, the end of figuration, the abandonment of art as representation, signification, narrative, though it involves the retention of the body, planes, and colors, which it extracts from the figurative. The figural is the deformation of the sensational and the submission the figurative to sensation. It is the development of art as an "analogical language," a nonrepresentational "language" of colors, forms, bodily shapes, screams.[36]

35. "In the end, it was abstract painting that produced a purely optical space and suppressed tactile referents in favor of an eye of the mind: it suppressed the task of controlling the hand that the eye still had in classical representation. But Action Painting does something completely different: it reverses the classical subordination, it subordinates the eye to the hand, it imposes the hand on the eye, and it replaces the horizon with a ground" (ibid., 87).

36. "'Analogical language,' it is said, belongs to the right hemisphere of the brain, or better, to the nervous system, whereas 'digital language' belongs to the left hemisphere. Analogical language would be a language of relations, which consists of expressive movements, paralinguistic signs, breaths, and screams, and so on. . . . More generally, painting elevates colors and lines to the state of language, and it is an

I myself have nothing particular invested in this schema, which, while contestable, is certainly not an exhaustive overview of the art of the last one hundred years or so. I am more interested in looking at an art that had barely emerged when Deleuze wrote his study of Bacon's paintings and in seeing how useful or relevant Deleuze's conception of the arts may be to how we can understand the art of the western desert artists of Australia.[37] I don't want to suggest that contemporary Aboriginal art is Deleuzian, for no art is Deleuzian. At best Deleuze provides some concepts that are useful, or not, for understanding another dimension of the various arts than is available to sensation or vision alone; as a philosopher, Deleuze can provide us with a way of thinking the same forces as the arts address.

Western desert art is fascinating not only because it comes out of a nomadic tradition that has had little to do with Western art practices until less than four decades ago[38] but also because it directly

analogical language. One might even wonder if painting has not always been the analogical par excellence" (ibid., 93).

37. There is something about Western desert art that corresponds quite closely to the interpretive practices associated with abstractionism, which may be why there was a relatively ready acceptance of indigenous artists almost from the beginning: "The basic Western desert painting techniques: the dots, the lines, the monochrome backgrounds, the effects of super-imposition, are basic to modern western painting also—which is why the results looked to audiences of the 1970s and the early 1980s like modernist abstracts. But the painters derived all these methods originally from their own ceremonial paintings and the ancient rituals of the ground mosaic. The classic Western Desert painting ambiguously depicts actual geographical ceremonies in which these connections are re-affirmed by the Dreaming's custodians. These contents are fused into a coherent visual image using a code of abstract symbolism which makes modern western experiments with abstraction look naïve" (Art Gallery of South Australia 26).

38. The inception of dot painting using acrylic paints and canvas can be very precisely located in 1971, when Geoffrey Bardon began working with members of the local community to create a mural in western art materials for the Papunya School and the subsequent creation of the Papunya Tula Artist's cooperative. See Bardon's own account (2005); and Nicholls and North 2001:19ff for a more detailed history of the Western desert painting movement.

defies the categorizations by which twentieth-century Western art has been described. Instead of falling into the stylistic schools of either abstraction or expressionism, or the "middle" position of the figural, much of western desert art, including acrylics as well as prints, batiks, carvings, and sculptures, seems to occupy all three positions simultaneously. These arts share an obsession with a mystical code (or many) and a fascination with the geometrical forms and with abstraction. They are also concerned with the direct expression of rhythm and force, movement and embodiment that characterizes expressionism. But no less concerned with the figure than in the works of Cézanne or Bacon, the figure, alone, coupled, boxed in, deformed, subjected to invisible forces, is as explicitly the object of sensation in these various works; in addition, while figural, they must also be understood as landscapes, in Maldiney's sense, spatializations of lived space that nevertheless can also be mapped and coordinated, can function also geographically.

While I have no particular expertise in the art of the western desert (or, for that matter, in any art) and do not want to speak of and for works that are now loquaciously able to articulate their concerns more directly, I do nevertheless want to look at some works to see how they link territory, animality, and the earth together to

39. There are, of course, real risks of romanticizing the works of these profound artists and of submitting their works, pictorial and sonorous, to a kind of Westernized translation that robs them of their own autonomy and the location of these works within their own cultures and histories. It may be that any mention of such work in a text such as this, written primarily for a Western audience, already performs such a robbery. But it is also the case that Western desert artists seek an audience (to come), present and sell their works to Westerners and are prepared, even if highly elliptically, to discuss their work in English. It is significant that many of the leading artists of the first generation of Western desert artists sought recognition not only within Australia, and from Australian institutions and galleries and the state itself, but also from Europe and the United States. See, for example, Johnson's discussion of Clifford Possum's interest in travel abroad; or Nicholls and North's discussion of Kathleen Petyarre's American travels. It is also true that the younger generations of painters are no less consciousness of the "European" world that surrounds and sometimes engulfs them and the place of painting in their peoples' gaining some access to the goods and services of use of them from and through "Europe."

generate sensations.[39] Through looking at a few examples, we can see how Deleuze's speculations about art and sensation, art and the earth, and art and the body may be supported in relation to these works from a very different tradition of narrative, representation, and temporality.

That there is nothing primitive about western desert art ought to be made clear. It is not a timeless traditional indigenous art form, but rather a very recent contribution to contemporary art.[40] The technical and aesthetic proficiency and beauty of these works is obvious; younger artists are trained by older, more experienced, and respected artists in both traditional techniques and in the acquisition of new, ever changing procedures, methods, and colors. Works are often collective and commonly involve more than a single artist, often including many members of one's family or those who share one's dreaming, and thus lineage, filiation, totemic identifications, territory, and history. While art is part of everyday life to the extent that it pervades the visual images, activities, and artifacts of desert culture, nevertheless, art making is a special activity, invested with not only respect and authority in traditional communities; it has become one of the few means by which Aboriginal peoples have

40. There is a clear separation in the minds of the artists themselves between the traditional methods, materials, and practices, which are directly derived from the earth, and those introduced through "European" techniques from the early 1970s and an easy ability to move between the one and the other as the situation warrants. The acrylic and oil paintings have never represented themselves as traditional or tribal, though they are always marketed through the narratives, the dreamings, that each work of art apparently depicted: "That Dreaming been all the time. From our early days, before the European people came up. That Dreaming carry on. Old people carry on this law, business, schooling, for the young people. . . . They been using the dancing boards, spear, boomerang—all painted. And they been using them on the body different times. Kids, I see them all the time—painted. All the young fellas, they go hunting and the old people there—they do sand painting. They put down the story, same like I do on the canvas. . . . Everybody painted. They been using ochres—all the colors of the rock. People use them to paint up. I use paint and canvas—that's not from us, from European people. Business time, we don't use the paint the way I use them—no we use them from rock, teach 'em all the young fellas" (Clifford Possum, quoted in Johnson 2003:16).

acquired financial and social support from white culture without complete paternalism and condescension. This is not the place to provide an adequate analysis of the complex and mired history of these gloriously dynamic, resonating, and unique artworks,[41] which are, in my humble opinion, among the most stunning, affecting, and least understood and appreciated works of the twentieth and twenty-first century and beyond, although there is now an avid international art market growing around the production and sale of these magnificently shimmering works.

I can really only undertake a sampling—the briefest of detours— and look at the work of two major artists from the western desert: Kathleen Petyarre (from Anmatyerr, a region northeast of Alice Springs, painting at Utopia) and Clifford Possum Tjapaltjarri (also an Anmatyerr, painting at Papunya), two of the most internationally well-known indigenous artists, whose work has now been exhibited in the U.S., the UK, France, and elsewhere, and certainly the most well-known in Australia and well represented in the collections of the National and State Galleries. The work of each is an attempt to map out in spatial and figural terms the geography of their dreaming country, a cartography of the events, the topography, and the animal beings that link to the artist's own bodily and clan history. Their works are temporal maps of those ancestral spatial terrains that are distinguishable and significant not for their geographical features but for the life a geography sustains, the practices that it engenders and the movements it requires. These works are dynamic portraits of a long past history, a history of events of war, natural destruction, births, marriages, sexual alliances, animal ancestors and totems, a living history concerned primarily with the past and how its narratives and practices effect the present, like the cinematic reel compressed into a single highly complex frame. Many of these works are remarkable for their capacity to envision, from an aerial point of view, the detailed topography of a land that has been

41. See the writings of Johnson 2003, Nicholls and North 2001, Hylton 1996, and especially Bardon 2005 for further details about the history and marketing of the major artworks of the Pintupi, Papunya, and Utopia artist communities.

primarily traversed only by foot, in which the slightest undulations or natural feature, tree trunks or animal remains may hold ceremonial and ancestral significance. Maldiney's landscape coincides here with a geography that now also includes history.

It may be true that abstraction and spatial representation were acquired as survival skills in an extremely harsh and relentless terrain and climate, but, rather than being simply the results of a kind of natural selection, an evolution concerned with survival alone, these conditions, the territory in its harshness and in its minute richness, become the basis of all ceremonial representations and, eventually, artistic representations that tend to retain their ceremonial connections but move well beyond the traditional.[42]

To take only one example from Kathleen Petyarre's productive oeuvre as one of the Utopia artists, she shares a Dreaming with a number of her painter sisters and brothers,[43] the mountain or thorny devil Dreaming. This particular story involves a typical conjunction of territory and animal, of animal traversing territory, of territory inscribed by animal movements and the qualities and sensations capable of being released through their coupling, the

42. "Such an ability—to orientate oneself in space by envisioning a large tract of land as an entity that comprises smaller parcels of land, then conjuring up the whole in abstract form and reproducing it visually—was necessary for survival. In fact, successful land navigation and its corollary, the capacity for accurate location of food and water were essential for group survival. Collectively, these invocations of large stretches of 'country' constitute 'aerial views' of particular tracts of land" (Nicholls and North 2001:7).

43. Utopia is a somewhat misnamed generic label for about twenty small settlements in the Northern Territory of Anmatyerr and Alyawarr speaking groups. Petyarre worked for nearly twenty years, from 1969–1988 as an assistant teacher at the Utopia school that educated the children from these groups. Shortly after the opening of the Papunya art school, Utopia also developed into an artists' community, primarily directed to the production of works by women artists. Petyarre and her many sisters, including Violet, Gloria, Myrtle, and Nancy Petyarre, began as batik- and printmakers and only turned to painting in the 1980s. She had her first solo exhibition in 1996. The land around Utopia was returned to its traditional owners after a land claim, made primarily on behalf of women and their ceremonial ties to the land, in 1980.

eruption of colors, speed, and stillness, of terrain illuminated by reptile movements and through the humanized history of reptile ancestors. Petyarre and her sisters each produce mountain devil Dreaming in a series of remarkable paintings, each varying minutely, each taking a different element or aspect of the same Dreaming and extracting from it a vibrating series of dots, which resonate, op-art style, not just with optical but above all with haptic effects that reproduce while transforming the devil-movement through linking it to the becoming of the terrain or landscape. Devil-skin marks the land, devil-arcs of movement provide paths or tracks for lines of flight that transform hostile earth into territory.

The mountain devil (called *arnkerrth*) is a very small, spiky, ominous-looking lizard that inhabits much of the central Australian desert. It has the remarkable capacity, chameleonlike, to transform itself, to augment visual qualities. It usually has an ochre and earth coloring, especially in sedate and unthreatening conditions. It moves in a characteristic semicircular path, leaving parallel tracks that inflect in a gentle arc of circular movements, then back again, snaking in one direction then in another, creating an undulating pathway as it heads in a particular direction. It can freeze without any trace of movement on viewing possible predators and, when threatened, can change color very rapidly from its ochre coloring to brilliant reds and yellows and then change back to its ochre/olive coloration again when it feels safe. The mountain devil, as a wily and wise character, a traveler or nomad, has many adventures and must rely on her skills and wisdom to survive. Kathleen Petyarre and her sisters have grown up, have studied, and, in some sense, have become, through these Dreaming stories, the hardy and "artistic" creatures who make their own bodies into a canvas of predator-sensations.

None of Kathleen Petyarre's paintings provide an image, resemblance to, or portrait of the mountain devil, but each is a becoming-devil of paint itself, the coming alive of the corrugations and patterns of its skin, of its tracks, the arcs of its movements as well as the projection of the skin onto the terrain, the belonging together of both the skin, the movements of the devil over its terrain,

the home country of Kathleen and her people (the people of the Atnangker), and the earth and its secret locations, which sustains them all through its own excesses and their ingenuity.[44]

The terrain, a two hundred square kilometer area in the eastern desert of central Australia, is mapped in detail in a number of massive, elaborate paintings that contain not only a spatial, almost aerial, "map" but also the history of the animal and human events that occur there, from the ancient and more recent past, not only the time of the Dreaming but also incorporating events from memory or circulating narratives—the massacre in Darwin in 1869, the Coniston massacre of Aboriginal peoples in the 1920s, various devastating bushfires, the movement of forced and voluntary migrations from traditional lands through the intervention of various governmental policies and ordinances directed to assimilation into white culture, including the most recent and invasive government interventions into child-raising practices, which continue a long tradition of violent even genocidal assimilation and annihilation.[45]

44. "In Kathleen's art, as is the case with other Anmatyerr, Centralian, and Western Desert artistic production, *Arnkerrth* [the Mountain Devil] is not represented figuratively but conceptualised spatially. In Anmatyerr art all living creatures, including human beings, are depicted as predominantly spatial rather than psychological beings, interacting in natural and cultural landscapes that occupy space over time. . . . The spatial information or patterns that Kathleen creates in her art correspond to and can be mapped onto existing geographic features in Atnangker country, for example, the rockholes, hills and mulga spreads that Arnkerrth encountered in the course of her epic travels during the Dreaming. Satellite imagery and computer-generated overlays indicate a surprisingly close correspondence to the work of traditionally oriented Indigenous artists, including that of Kathleen Petyarre" (Nicholls and North 2001:10). Johnson makes a similar point: "The peoples of the Western desert are justly renown for their uncanny mastery of their terrain and its resources. Their phenomenal skills of site location, tracking and spatial orientation in apparently featureless country almost defy explanation for those dependent on maps to find their way around. . . . They do not need to read directions off a map because they know how to read the ground itself" (2003:79).

45. As this text is being finalized, the Australian government has announced, just in time for the next elections, that it needs to intervene into the alarming rate of child rape and child sexual abuse that has occurred in many remote indigeneous

In Petyarre's work the land, the mountain devil, the weather, and catastrophic events that occur to the land—hail, storms, drought, fire, sandstorms—are not readily distinguishable from one another, rather the one is incorporated into the other, the skin is part of the land, the land is made by what occurs on it and has its particular effect on the events that are hitherto marked by their origins, and the people who inhabit the land, including the artists who sing and paint its ceremonies and make "white man's art" as a second-order representation of the art that is part of their own cultural life. Yet, "it's still body painting, still ceremony, even looking from the sky [it is] still dancing, still ceremony, my new style is still dancing ceremony" (Kathleen Petyarre, quoted on Nicholls and North 31). Sensations are liberated from their religious and sacred position in the rituals that help in the transmission of knowledges from one generation to the next (while never thoroughly detached from these origins) to become coloring, forming, artworks that "stand up alone," that function perfectly well as autonomous objects, as artworks, in other nonceremonial contexts. Though their sacred relations remain implicit in such artworks, they are no longer sacred objects or part of sacred ceremonies.

Clifford Possum Tjapaltjarri was probably the most well-known indigenous artist of his generation, second only in fame to Emily Kame Kngwarreye's luminous works (an aunt to Kathleen Petyarre and the yardstick or measure of white success for many indigenous artists in terms of her acceptance by museums, galleries, and auction houses). Originally a woodcutter and carver of considerable

communities. While of course it is laudible to "protect children," it is significant that in the same week that the prime minister, John Howard, chose to bring in troops to address this issue (a new "war" on abuse?), newspapers revealed that more than fifty million dollars of government funds specifically earmarked for Aboriginal communities has been left unspent. In other words, rather than actually provide and disburse the money that should have been spent on health, educational, and employment services, the government has chosen a path that cannot possibly adequately address child sexual abuse and will only further participate in the alienation of Aboriginal peoples from both their own traditional life and lands as well as their involvement in white culture as autonomous subjects.

skill, he joined the Papunya Tula Artists Cooperative in 1972, becoming chairperson of the cooperative in the early 1980s. His most stunning and complex works, like Kathleen Petyarre's, were huge paintings, undertaken as a kind of elaborate map or topography of his people's Dreaming. His early paintings on walls and boards, including the Warlugulong series (mid to late 1970s), were focused on painting the Dreaming of a catastrophic bushfire, which was the result of a long series of transgressions by two brothers.

Significantly, he painted this series with his brother, Tim Leura Tjapaltjarri. Warlugulong is the Anmatyerr name for a site around two hundred miles from Alice Springs where the Blue-Tongued Lizard Man started a great bushfire, the primordial or original bushfire, one of the Dreamings of the "origins of the earth" where his two sons perished. However, it may be that the two sons perished because they ate all of a sacred kangaroo without sharing with their father or group, a double-barreled crime or transgression that demanded the severest punishment. The Warlugulong paintings are topographical diagrams of the sons, the fire, the father, the kangaroo, painted as if they were sand paintings, on the ground, where their orientation and the location of up and down becomes irrelevant.[46] The bushfire Dreaming repeats and elaborates sensory motifs and regions of the Warlugulong series, the skeletons of the two brothers bringing more and more dynamic and less traditional colors to canvases now saturated with Dreaming stories, placed together instead of separated on the canvas.

For Clifford Possum and his patrilineal descent group, the primary Dreaming explicated in the Warlugulong series and in many other paintings he and his brother undertook is the Love Story, a story with a number of episodes, one that involves a man named Liltipility who falls in love with his classificatory mother, a relative with whom he is forbidden various types of contact, especially

46. "Like almost all Western desert paintings, Warlugulong was painted flat on the ground [like Pollock's work]. This displaces the European assumption that the top of the painting must, like a western map, be north, with a perspective from which there are only four sides, any of which might be the top depending on which side of the canvas the artist is located at the time" (Johnson 2003:89).

sexual contact. The paintings that make up the Man's Love Story series are all intensive visual interpretations of elements of this narrative. Many of his paintings are episodes or fragments of this Dreaming, explorations of sites and locations where it took place and of animals and insects who shared this terrain, including honey ants, rock wallabies, and possums, that figure heavily in some of his art.

Yet his art, and that of other desert artists, cannot be construed as narrative or representational or sacred. If there is a narrative or representation, it is only that which is captured visually, technically. This is perhaps why the story of the Dreaming is commonly appended to artwork as an external document, a written narrative sold with each painting, a kind of authentification for Western eyes of the ceremonial value of these works. As embedded as they are in history and collective narrative, however, these contemporary works require an artistic pop, "a flash," in Clifford Possum's own words, the eruption of sensation at the level of the artwork itself to work as contemporary artworks rather than to serve only as non- or preartistic religious rituals.[47]

Their colors are as dazzling, iridescent, and luminous as territorial deep sea fish. The dots make the landscape sing and dance with a buzzing resonance of poster display.[48] But here it is not only the (animal) body that is on display, rendered sensational, but the very earth itself, with every feature, characteristic, and undulation, every shrub or tree, now laden with its events, the very forces necessary for a sensory elevation of color to the "cry of the earth," more

47. When asked by Vivien Johnson what gave him the idea to compress two or more stories into a single artwork, he answers: "Nobody. My idea. I think, I do it this way: make it flash" (ibid., 79).

48. Clifford Possum was very aware that the traditional ocher palate, colors derived directly from the earth and its products, had become predictable, perhaps even clichaic, and he sought out, through combining ochers and the use of Western acrylics, a new range of colors, and with them new possibilities of sensation: "I gotta change'm see? Make'm nice colours. Nobody try to mob me on this, because colours—I gotta change'm. I tell'm everyone, soon as I saw my canvas, I gotta be changing colours. Not only this same one, same one—colours, I change'm all the way along. Gotta be different" (Clifford Possum, ibid., 180).

clearly here a summoning of a "people to come" perhaps than in any other form of art today!

This is not an art that is understood conceptually.[49] Its effect is largely visceral, dazzling the eyes with color vibrations, beckoning hands to touch and ears to hear its shimmering forms, its stories of origin, its rhythms and movements that are both abstract and realist, both representational and antirepresentational in one and the same canvas, disorienting our optical and spatial coordinates in favor of a more haptic understanding of terrain or earth and of its relation to the living, struggling, producing body while nonetheless retaining a new kind of optic, producing a new kind of landscape perhaps even more decentered than postmodernism itself. There is no ready distinction between background and foreground, no figure discernible against a neutral ground, no active subject, only becomings, animal-becomings, honey-ant-becomings, and territorial-becomings, the becoming of anthills and honey mounds, of fires and natural catastrophes.

The very forces and energies of the earth and all that populates it are summoned up and become sensation. Even the most elementary forms of life, plants, for example, make of their situation, their territory, climate, and milieu a contraction, a making of something more—colors and perfumes that motivate and provide materials for art.[50] Everything—territory, events, animals, man—are pro-

49. Clifford Possum himself has suggested that his work less involves "brain" than "heart": "'Soon as I pick up my brushes, I got'm in my head.' What an amazing brain he must have, I exclaimed, to be able to conceive such a complex image in advance of its creation. He gently corrected me. 'Not brain, Nakamarra.' He said to me, 'Not brain—heart'" (ibid., 185).

50. In a quite stunning passage, Deleuze and Guattari affirm, along with Bergson and Darwin himself, the remarkable inventiveness—freedom—of even the most apparently dormant of life forms. Plant-becomings are evident everywhere for Bergson, and plants retain for him an incipient consciousness, a kind of elementary freedom linked to their possibilities of movement. Deleuze and Guattari, however, suggest that plants are contemplative, they have passions, they contract to produce sensations: "The plant contemplates by contracting the elements from which it originates—light, carbon, and the salts—and it fills itself with colors and odors that in each case qualify its variety, its composition: it is sensation in itself. It is as if flowers smell themselves

duced equally, without hierarchy, on the flat plane of canvas or board, the weather no more enveloping human and animal figures than being enveloped by them, humans no more the object of representation than the animals to which they are ancestrally connected, the earth no more a passive ground for the action of living agents than a living agent (or many) itself.

These works exhibit a preoccupation with becoming, with duration and the virtual. They are concerned above all with the time that passes and marks events but also with the time that marks eternity and the unchanging. They are concerned with that virtuality that constitutes history, cultural and natural memory, the memory of events, of seasons and their practices, of upheavals and changes, a history conserved and condensed into the present as the present's conditions for its own overcoming into a new future. These works represent a surveying-without-distance, an absolute survey, a self-surveillance, in Ruyer's sense,[51] a history both indigenous and alien, both autonomous and brutally colonized, a history now embedded in the land and the living creatures it supports, that the paintings celebrate even as they look forward to a time in which the earth is returned to them. Is this not precisely the kind of territorializing, deterritorializing, and reterritorializing structure, hovering between the animal and the human, between the earth and territory, that Deleuze has claimed is the basis of all the arts? And don't these indigenous artists, and the many others with their blazing vision

by smelling what composes them, first attempts of vision or of sense of smell, before being perceived or even smelled by an agent with a nervous system and a brain" (Deleuze and Guattari 1994:210).

51. For Ruyer, sensations are the consequences the activities that do not themselves require a sensibility to perceive them. Vision, hearing, smell, touch, and taste are sensory experiences, not mediated representations of the real, but the real itself in absolute self-proximity, true form: "It is a primary, 'true form as Ruyer defined it: neither Gestalt nor a perceived form but a *form in itself* that does not refer to any exterior point of view, any more than the retina or striated area of the cortex refers to another retina or cortical area: it is an absolute consistent form that surveys *itself* independently of any supplementary dimension, which does not therefore appeal to any kind of transcendence" (Deleuze and Guattari 1994:210). See both Ruyer 1952 and, for an insightful elaboration of his claims, Bains 2002.

of the earth and its possibilities for life, make sensation the means by which their very culture and not just its arts can live again, live anew? Is this not a gesture to the multisensory unity of the arts where painting summons up and incites song and dance and where narratives, transformed into song, dance, musical rhythms and themes, become the very emblems or posters of the earth itself and the future life it might sustain?

BECOMING COSMIC

Painting has been about the visual and plastic image of the invisible forces of the earth, forces that are the combination of universal forces regulating all the cosmos—gravitational forces, magnetic forces, the force of light, and so on—and the historically contingent eruption of life on earth in the particular forms it has taken—forces that are cellular, chromosomal, biological, regulated by impersonal cosmic forces through which evolution operates. Painting is one response, by no means the only possible one, to the dynamization of biologically regulated forces (forces of both the body and the Body without Organs) by cosmic forces, through the random production of excess. Life has no choice but to respond to these random cosmological forces, which it must incorporate into its morphology and behavior. In addition to the necessities imposed on life by these forces of the universe (to take as some obvious examples, the separation of day from night or light from dark, the separation of oceans and waters from the earth and dry land, the geological separation of continents and migrational pathways, the effects of specific regional, climatological and geographic features on life forms), there is also the production by these forces of an excess, of more than living creatures need to survival.

Bare survival is rare in even the harshest climate and conditions: the more difficult the region, the more ingenuity and artistry is involved in the production of (random) qualities. The thorny mountain devil is capable of survival in even the driest of climates because it is able to live on the water generated only by condensation. Yet it does so much more than survive. Not only does it produce the most

vivid and striking colors and color changes, it has also perfected the theatrical arts of stillness and speed. And not only does it manage to survive in the most forbidding of conditions, it also inspires totemic identifications, it serves for many Aboriginal peoples, and through them, perhaps "Europeans," as an emblem, a Dreaming, of many of their own struggles and triumphs, both daily and historically. It is because there is an animal-becoming, a devil-becoming, in the coexistence of traditional groups and the thorny mountain lizards in a common terrain, where each fights in its own way, that human subjects become inscribed with animal-becomings, the movements, gestures, and habits of animal existence (which is not confined to the visual arts, but occurs above all in dance and music) and that animal, even lizard subjects, become endowed with human wishes and skills, wisdom, fortitude, cunning, calm, envy, gratitude.

Cosmic forces—of climate, geography, temporality—impinge on, transform, and become the objects for living beings. We can understand these as the coming together, however uncomfortable, of an interior milieu with an exterior milieu, an unpulsed organic totality, and vibratory cosmic forces that generate the possibilities of expression and intensity. These living beings take what they need from the objects produced by such cosmic forces, but also more than they need. They extract that which may not be of survival value—colors, sounds, shapes—qualities that only emerge as such to the extent that they can be extracted or abstracted from the objects in which they are found and taken from this excess to become pleasurable and intensifying qualities that can be used to adorn both territory and body. Territory and body only emerge as such to the extent that such qualities can be extracted.

There is only earth rather than territory until qualities are let loose in the world. Qualities and territory coexist, and thus both are the condition for sexual selection and for art making—or perhaps for the art of sexual selection and equally the sexuality of art production. It is this excess, of both harnessable forces and of unleashed qualities, that enables both art and sex to erupt, at the same evolutionary moment, as a glorification of intensity, as the production and elaboration of intensity for its own sake. Where art comes to use sensations, the condensation, purification, and exploration

of percepts and affects; sex comes to use embodied gestures, traces, connections from which the percept or affect may be born. It is because of the beauty of the thorny lizard, its peculiar epidermal geography, its characteristic ways of moving, its color intensifications, that it serves to spur on human art making, which does not so much seek to imitate or represent it as to partake in some of those features and characteristics that allure and attract.

Art is the process of making sensations live, of giving an autonomous life to expressive qualities and material forms and through them affecting and being affected by life in its other modalities. As songbirds are themselves captivated by a tune sung by their most skillful and melodious rivals and fish are attracted to the most striking colors and movements of fish, even if these are not their own, so these qualities—melody, sonorous expression, color, visual expression—are transferable, the human borrows them from the treasury of earthly and animal excess. But art is not simply the expression of an animal past, a prehistorical allegiance with the evolutionary forces that make one; it is not memorialization, the celebration of a shared past, but above all the transformation of the materials from the past into resources for the future, the sensations unavailable now but to be unleashed in the future on a people ready to perceive and be affected by them.

Cézanne yearns for a future in which the solidity of objects and forces can be felt, sensed, real; Bacon yearns for a future in which reality directly impacts the nervous system, where forces are liberated from their artistic boundaries; Papunya and Utopia artists yearn for peoples, Aboriginal and white, reconnected to their lands, no longer only through animals but through what the West has to offer them, through planes and cars, through Europe, as a world people, as custodians of a world-Dreaming. In making sensation live, each evokes a people and an earth to come, each summons up and pays homage to imperceptible cosmic forces, each participates in the (political) overcoming of the present and helps bring a new, rich, and resonating future into being.

BIBLIOGRAPHY

Alliez, Eric. 2004. *The Signature of the World: What Is Deleuze and Guattari"s Philosophy?* New York: Continuum.

Art Gallery of New South Wales. 2004. *Tradition Today: Indigeneous Art in Australia.* Sydney: Art Gallery of NSW.

Bains, Paul. 2002. "Subjectless Subjectivity." In Brian Massumi, ed., *A Shock to Thought: Expressionism After Deleuze and Guattari,* 101–116. London: Routledge.

Bardon, Geoffrey. 2005. *Papunya—A Place Made After the Story: The Beginnings of the Western Desert Painting Movement.* Melbourne: Melbourne University Press.

Bergson, Henri. 1946. *The Creative Mind: An Introduction to Metaphysics.* Trans. Mabelle L. Andison. New York: Philosophical Library.

——— 1988. *Matter and Memory.* Trans. N. M. Paul and W. S. Palmer. New York: Zone.

Bogue, Ronald. 1996. "Gilles Deleuze: The Aesthetics of Force." In Paul Patton, ed., *Deleuze: A Critical Reader,* 257–269. Oxford: Blackwell.

———— 1999. "Art and Territory." In Ian Buchanan, ed., *A Deleuzian Century*, 85–102. Durham, NC: Duke University Press.

———— 2003a. *Deleuze on Music, Painting, and the Arts*. New York: Routledge.

———— 2003b. "Minority, Territory, Music." In Jean Khalfa, ed., *An Introduction to the Philosophy of Gilles Deleuze*. Continuum: London.

Buchanan, Ian, 2000. *Deleuzism: A Metacommentary*. Durham, NC: Duke University Press.

Buchanan, Ian and Marcel Swiboda, eds. 2004. *Deleuze and Music*. Edinburgh: University of Edinburgh Press.

Cache, Bernard. 1995. *Earth Moves: The Furnishing of Territories*. Trans. Anne Boyman. Cambridge: MIT Press.

Chatwin, Bruce. 1987. *The Songlines*. New York: Viking.

Colebrook, Claire. 2002. *Understanding Deleuze*. Sydney: Allen and Unwin.

———— 2006. *Deleuze: A Guide for the Perplexed*. London: Continuum.

Darwin, Charles. 1981. *The Descent of Man, and Selection in Relation to Sex*. Princeton: Princeton University Press.

———— 1996. *The Origin of Species*. Oxford: Oxford University Press.

Dawkins, Richard. 1989. *The Selfish Gene*. Oxford: Oxford University Press.

Deleuze, Gilles. 1990. *The Logic of Sense*. Trans. Constantine Boundas. New York: Columbia University Press.

———— 2003. *Francis Bacon: The Logic of Sensation*. Trans. Daniel W Smith. Minneapolis: University of Minnesota Press.

Deleuze, Gilles and Michel Foucault. 1999. *Gérard Fromanger: Photogenic Painting*. London: Black Dog.

Deleuze, Gilles and Félix Guattari. 1987. *A Thousand Plateaus: Capitalism and Schizophrenia*. Vol. 2. Trans. Brian Massumi. Minneapolis: University of Minnesota Press.

———— 1994. *What Is Philosophy?* Trans. Hugh Tomlinson and Graham Burchell. New York: Columbia University Press.

Dennett, Daniel. 1996. *Darwin"s Dangerous Idea: Evolution and the Meaning of Life*. New York: Touchstone.

Derrida, Jacques. 1987. *The Truth in Painting*. Trans. Geoffrey Bennington and Ian McLeod. Chicago: University of Chicago Press.

Due, Reidar. 2007. *Deleuze*. Cambridge: Polity.

Foçillon, Henri. 1992. *The Life of Forms in Art*. Trans. Charles Beecher Hogan and George Kubler. New York: Zone.

Freud, Sigmund. 1908. "Civilized Sex Morality and Modern Nervous Illness." In *Standard Edition of the Complete Psychological Works of Sigmund Freud* 9:177–204. London: Hogarth.

——— 1917. "Some Thoughts on Development and Regression— Aetiology." In *Standard Edition of the Complete Psychological Works of Sigmund Freud* 16:39–357. London: Hogarth.

Genosko, Gary. 2002. "A Bestiary of Territoriality and Expression: Poster Fish, Bower Birds, and Spiny Lobsters." In Brian Massumi, ed., *A Shock to Thought: Expressionism After Deleuze and Guattari*, 47–59. London: Routledge.

Grosz, Elizabeth. 2001a. *Architecture from the Outside: Essays on Virtual and Real Space*. Cambridge: MIT Press.

——— 2001b. "The Strange Detours of Sublimation: Psychoanalysis, Homosexuality and Art." *Umbra: A Journal of the Unconscious*, 141–153.

——— 2004. *The Nick of Time: Politics, Evolution, and the Untimely*. Durham, NC: Duke University Press.

——— 2005. *Time Travels: Feminism, Nature, Power*. Durham, NC: Duke University Press.

Hallward, Peter. 2006. *Out of this World: Deleuze and the Philosophy of Creation*. London: Verso.

Hainge, Greg. 2004. "Is Pop Music?" In Ian Buchanan and M Swiboda, eds., *Deleuze and Music*, 36–52. Edinburgh: University of Edinburgh Press.

Hartshorne, Charles. 1973. *Born to Sing*. Bloomington: Indiana University Press.

Hylton, Jane, with Ron Radford, eds. 1996. *Dreamings of the Desert: Aboriginal Dot Paintings of the Western Desert*. Adelaide: Art Gallery of South Australia.

Jankélévitch, Vladimir. 2003. *Music and the Ineffable*. Trans. Carolyn Abbate. Princeton: Princeton University Press.

Johnson, Vivien. 2003. *Clifford Possum Tjapaltjarri*. Adelaide: Art Gallery of South Australia.

Jourdain, Robert. 1997. *Music, the Brain, and Ecstasy*. New York: Harper-Collins.

Leroi-Gourhan, André. 1993. *Gesture and Speech*. Trans. Anna Bostock Berger. Cambridge: MIT Press.

Lingis, Alphonso. 1984. *Excesses: Eros and Culture*. Albany: SUNY Press.

———2005. *Body Transformations: Evolutions and Atavisms in Culture*. Routledge: New York.

———2007. *The First Person Singular*. Evanston: Northwestern University Press.

Lorenz, Konrad. 1974. *On Aggression*. Orlando: Harvest.

Lyotard, Jean-François. 1971. *Discours, Figure*. Paris: Klincksieck.

Maldiney, Henri. 1973. *Regard Parole Espace*. Lausanne: L'Age d'Homme.

Merleau-Ponty, Maurice. 1968. *The Visible and the Invisible*. Trans. Alphonso Lingis. Chicago: Northwestern University Press.

Meyer, Leonard B. 1956. *Emotion and Meaning in Music*. Chicago: University of Chicago Press.

Miller, N. 2001. "Evolution of Human Music Through Sexual Selection." In N. L. Walllin, B. Merker, and S. Brown, eds., *The Origins of Music*, 329–360. Cambridge: MIT Press.

Mithen, Steven, 2005. *The Singing Neanderthals: The Origins of Music, Language, Mind, and Body*. London: Weidenfeld and Nicolson.

Nicholls, Christine and Ian North, eds. 2001. *Kathleen Petyarre: Genius of Place*. Adelaide: Wakefield.

O'Sullivan, Simon. 2006. *Art Encounters: Deleuze and Guattari, Thought Beyond Representation*. London: Palgrave MacMillan.

Pinker, Steven. 2000. *The Language Instinct: How the Mind Creates Language*. New York: Harper Perennial.

Preziosi, Donald, ed. 1998. *The Art of Art History: A Critical Anthology*. Oxford: Oxford University Press.

Rajchman, John. 2000. *The Deleuze Connections*. Cambridge: MIT Press.

Ruyer, Raymond. 1952. *Néo-Finalisme*. Paris: PUF.

Smith, Daniel W. 1996. "Deleuze"s Theory of Sensation: Overcoming the Kantian Duality." In Paul Patton, ed., *Deleuze: A Critical Reader*, 29–56. Oxford: Blackwell.

Storr, Anthony. 1992. *Music and the Mind*. New York: Ballantine.

Straus, Erwin. 1963. *The Primary World of the Senses: A Vindication of Sensory Experience*. Trans. Jacob Needleman. London: Collier-MacMillan.

Uexküll, Jakob von. 1957. "A Stroll Through the Worlds of Animals and Men." In Claire Schiller, ed., *Instinctive Behaviour: The De-*

velopment of a Modern Concept, 5–80. New York: International Universities Press.

—— 2001a. "The New Concept of Umwelt: A Link Between Science and the Humanities." *Semiotica* 134(1/4): 111–123.

—— 2001b. "An Introduction to Umwelt," *Semiotica* 134(1/4): 107–110.

Wilson, Edward O. 1980. *Sociobiology: The Abridged Edition.* Cambridge: Belknap.

Wöfflin, Heinrich. 1950. *Principles of Art History: The Problem of Development of Style in Later Art.* Mineola, NJ: Dover.

Worringer, Wilhelm. 1964. *Form in Gothic.* New York: Schocken.

Zahavi, Amotz, Avishag Zahavi, Na'ama Ely, and Melvin Patrick Ely. 1997. *The Handicap Principle: A Missing Piece of Darwin"s Puzzle.* Oxford: Oxford University Press.

INDEX

Aboriginals: art as financial/
social support for, 91–92;
artists, 3, 50*n*26, 89, 90*n*39,
93, 93*n*43, 94–96, 95*n*44,
97–98, 98*nn*47, 48, 99*n*49;
Coniston massacre of, 95;
government alienation and,
95*n*45
Abstract painting, 87*n*34, 88*n*35,
90; *see also* Art
Animals, 11; art originating
from, 11–13, 63–70; birds,
12, 36–40, 36*nn*10, 11, 52*n*
30, 67*n*7; honeybees, 42–43;
music and, 35–40, 41–43,
51*n*27; musical refrain and,
52*n*28; nature as counterpoint
and, 40–45; sexual selec-
tion and, 67*n*7, 68*n*8, 69*n*9;

spiders and, 44–45, 46–47;
ticks, 41–42, 42*n*19, 53;
vibration, sex, music and,
25–62; *see also* Music
Architecture: cosmos, chaos,
territory and, 1–24; framing
and, 10–17
Art: Aboriginal, 3, 50*n*26, 89,
90*n*39, 93, 93*n*43, 94–96,
95*n*44, 97–98, 98*n*48, 99*n*49;
aboriginals and financial/
social support using, 91–92;
abstract, 87*n*34, 88*n*35, 90;
aim of, 76*n*18; animals as
originators of, 11–13, 63–70;
body's relation to, 3, 11, 23,
73*n*12; capturing force of
time in, 86; chaos and genesis
of philosophy and, 5–10,

Art (*continued*)
9*n*7; chaos, cosmos, territory,
architecture and, 1–24; com-
monalties in, 71; earth and,
17–24, 63–103; earth, sensa-
tions, people and, 63–103;
evolutionary cycle of, 10–11;
expressionism, 90; forces of
space, time and nature with,
3; joy and, 76*n*17; materi-
als and, 60*n*38; ontology of,
1–2; philosophy's relationship
to, 2, 4, 5*n*4, 5*n*5; plane of
composition and, 28; politics'
relationship to, 2; sensations
and, 4, 7–8, 22, 59*n*36,
71–75, 73*n*12, 79, 100*n*51;
visual, 22; Western desert, 89,
89*nn*37, 38, 90–91, 92–95,
95*n*45, 97*n*46
Artist communities, 22*n*17,
48*n*24; Papunya, 92*n*41,
103; Pintupi, 92*n*41; Utopia,
92*n*41, 93, 93*n*43, 103

Bacon, Francis, 78, 81, 82*n*28,
89, 90; gravitational force
and, 86; isolation, deforma-
tion, dissipation and, 85
Bardon, Geoffrey, 89*n*38, 92*n*41
Bergson, Henri, 6, 74, 78*n*22;
intuition movement and, 85–
86; life forms, freedom and,
99*n*50; perception and, 78*n*22
Birds, 12; animals and, 52*n*30;
coloring and singing ability in,
37*nn*13–15, 49; music, emo-
tions, and songs from, 36–
40, 36*nn*10–11, 37*nn*13–15;
sexual selection and, 67*n*7

Body: art's relation to, 3, 11,
23, 73*n*12; forces of, 3*n*2;
rhythms of, 55; sensations
and, 80–81
Bogue, Ronald, 21*n*15
"Brain-becomings," 27*n*2
Buchanan, Ian, 3*n*4

Cache, Bernard, 11*n*10; architec-
ture and, 15–16
Cézanne, Paul, 73, 78, 90, 103;
iridescent chaos and, 84; logic
of senses and, 83
Chaos, 87; art and philosophy's
genesis in, 5–10, 9*n*7; cos-
mos, territory, architecture,
and, 1–24; infinite planes and,
28; iridescent, 84; life and,
26; music and, 20; painting
and, 88; science/philosophy's
attitude toward, 27*n*1; ways
to approach, 26
Chatwin, Bruce, 49
Choreography, 14*n*12
Colebrook, Claire, 56*n*33, 71*n*10
Composition, plane of: animals
and, 59–62; art and, 28;
framing and, 18, 24; music
and, 59–62; sensations and,
70–75, 77; sex and, 59–62;
vibration and, 59–62
Coniston massacre, 95
Cosmos: chaos, territory, archi-
tecture and, 1–24; painting
and, 101–3

Darwin, Charles, 6*n*6, 7, 49,
95; female/male vocalization
forms and, 31, 31*n*7, 34,
35; life forms, freedom, and,

99*n*50; music, sexual selection and, 29–35, 29*n*4, 30*n*5; sexual selection and, 65–70, 65*n*4, 68*n*8; songbirds and, 36*n*10, 36*n*11, 38

Dawkins, Richard, 65*n*5

Deformation, 85

"Deleuze and Pop Music," 4*n*3

Deleuze, Gilles, 1, 2, 3, 4, 5*n*4, 6, 8, 11*n*10, 22*n*17, 40, 41, 71, 78*n*22; architecture and, 17; art and, 10, 18*n*14, 20, 21*n*15, 35, 91; art, joy, and, 76*n*17; Bacon's paintings and, 89; chaos and, 87; figurative painting and, 88; form and, 84; geography and, 72; life forms, freedom, and, 99*n*50; life's self-satisfied solutions and, 86*n*32; music and, 57–58; planes and, 28*n*3, 70; refrain's basic components and, 52; science and, 27; sensations and, 80, 91; sexual selection and, 12, 69*n*9; territory, 46; vibrations and, 83

Dennett, Daniel, 65*n*5

Derrida, Jacques, 8, 8*n*8

Deterritorialization: music and, 53*n*31; territory and, 20–21, 24

Dissipation, 85

Dot painting, 89*n*38

Driesch, Hans, 43*n*21

Due, Reidar, 5*n*5

Earth and, art, 17–24

Earth, sensations, people, art and, 63–103

Emotions: birdsongs, music,

and, 36–40, 36*nn*10–11, 37*nn*13–15; see also Sensations

Expressionism, 90

Eyes: painting's relation to, 82*n*27; see also Visual transmutation

Figural painting, 88

Forces: bodily, 3*n*2; cosmic, 102; deformation, 85; diastolic, 85; dissipation, 85; gravitational, 86; isolation, 85; music as deterritorializing, 53*n*31; space, time, and nature, 3, 9*n*7; systolic, 84–85; time, 86; vibrational, 83

Framing and: architecture, 10–17; choreography and, 14*n*12; components, 14–15, 14*n*12, 15*n*13; partition's elementary form and, 14–15; plane of composition and, 18, 24

Freud, Sigmund, sublimation and, 64, 64*nn*2–3

Fromanger, Gérard, 76*n*17

Geography, 72

Government, alienation by, 95*n*45

Guattari, Félix, 2, 11*n*10, 20, 22*n*17, 35, 40, 46; architecture and, 17; geography and, 72; life forms, freedom, and, 99*n*50; music and, 57–58; planes and, 28*n*3, 70; refrain's basic components and, 52; science and, 27; sexual selection and, 12, 69*n*9

Hallward, Peter, 5n5
Hartshorne, Charles, 36n10
Honeybees, 42–43
Howard, John, 95n45
Hylton, Jane, 92n41

Intuition movement, 85–86
Iridescent chaos, 84
Irigaray, Luce, 2, 6n6
Isolation, 85

Jankélévitch, Vladimir, 25
Johnson, Vivien, 90n39, 95n44,
 98n47
Joy, art and, 76n17

Kandinsky, Wassily, 87
Klee, Paul, 87
Kngwarreye, Emily Kame, 96

Landscape painting, 72
Language, music's relationship
 to, 31
Lawrence, D. H., 73n14
Life, 26; forms, 99n50; self-
 satisfied solutions of, 86n32
Lingis, Alphonso, 51n27; sexual
 selection and, 66n6
Lorenz, Konrad, 48n24, 67;
 sexual selection and, 69n9

Maldiney, Henri, 71, 83, 90, 93;
 form and, 84
Malevich, Kazimir, 87
Merleau-Ponty, Maurice, 22, 83
Messiaen, Olivier, 58
Milieu, territory and, 45–51,
 47nn22–23

Mithen, Steven, 39n16
Mondrian, Piet, 87
Music, 20, 21n16; animals and,
 35–40, 41–43, 51n27;
 animals, refrain, and, 52n28;
 animals, vibration, sex, and,
 25–62; deterritorializing force
 of, 53n31; language's relation-
 ship to, 31; laws of nature
 and, 40; minor mode in,
 60n37; ontology of, 25, 46;
 sexual selection and, 29–35,
 29n4; sound expression and,
 57n34; spiders and, 44–45;
 territory's relationship to, 49;
 tones and, 55n32; vibration,
 refrain and, 51–59

Nature: art and forces of space,
 time, and, 3, 9n7; as counter-
 point, 40–45; music and laws
 of, 40–45
Nicholls, Christine, 89n38,
 90n39, 92n41
Nietzsche, Friedrich, 1, 10,
 25, 63
North, Ian, 89n38, 90n39,
 92n41

O'Keefe, Georgia, 78
Ontology: art, 1–2; music,
 25, 46
O'Sullivan, Simon, 73n13, 77n20
Other, sensations and becoming,
 75–81

Painters, 73, 78, 81, 82n28,
 83, 84, 87, 88, 89, 90, 103;
 younger-generation, 90n39

Painting: abstract, 87*n*34, 88*n*35, 90; action, 88*n*36; analogical language and, 88*n*35; chaos and, 88; cosmos and, 101–3; dot, 89*n*38; eye's relation to, 82*n*27; figural, 88; landscape, 72; sensations, 81–87; today, 87–101; visual transmutation of, 82, 82*n*28
Papunya artists communities, 92*n*41, 103
Papunya Tula Artist's Cooperative, 89*n*38, 97
Parasaurolophus, 55*n*32
Partitions, 14–15
People, earth, sensations, art, and, 63–103
Perception, 78*n*22
Petyarre, Gloria (sister), 93*n*43
Petyarre, Kathleen, 97; artwork of, 90*n*39, 93, 93*n*43, 94–96, 95*n*44
Petyarre, Myrtle (sister), 93*n*43
Petyarre, Nancy (sister), 93*n*43
Petyarre, Violet (sister), 93*n*43
Philosophers, 22*n*17
Philosophical intuition, 85*n*31
Philosophy: art's relationship to, 2, 4, 5*nn*4, 5; chaos and genesis of art and, 5–10, 9*n*7; plane of consistency and, 28
Pinker, Steven, 31
Pintupi artists communities, 92*n*41
Planes, 28*n*3, 70; chaos and infinite, 28; composition, 18, 24, 28, 59–62, 70–75, 77; consistency, 28; framing and composition, 18, 24; science and references, 28
Poetry, 34*n*9
Politics, art's relationship to, 2
Pollock, Jackson, 88
Possum, Clifford, 90*n*39, 91*n*40; artwork of, 96–98, 98*nn*47, 48, 99*n*49

Rajchman, John, 77*n*20
Refrains: animals and musical, 52*n*28; basic components, 52; cosmos composed of, 58; vibration, music and, 51–59, 52*nn*28–29
Rembrandt, 73
Rhythms, 55, 83*n*29; power of, 83
Ruyer, Raymond, 100; sensations and, 100*n*51

Science: plane of references and, 28; vibrations and, 62
Sensations, 80; art and, 4, 7–8, 22, 59*n*36, 71–75, 73*n*12, 79, 100*n*51; becoming cosmic and, 101–3; becoming other and, 75–81; body and, 80–81; dual energies of, 76; earth, people, art, and, 63–103; materials and, 60*n*38; painting, 81–87; plane of composition and, 70–75, 77; synthetic character of, 75*n*16; vibrations and, 62*n*40, 80, 80*n*25
Sensations, art and, 79, 91
Sex: animals, vibration, music, and, 25–62; instinct for, 64*nn*2–3

Sexual selection, 6, 6n6, 12, 65–
66, 65n6; animals and, 67n7,
68n8, 69n9; Darwin and,
65–70, 65n4, 68n8; music
and, 29–35, 29n4, 30n5
Significance, 2
Songs, bird, 36–40, 36nn10–11,
37nn13–15; see also Music
Sound expression, 57n34
Soutine, Chaim, 82n28
Space, art and forces of time,
nature, and, 3, 9n7
Spemann, Hans, 43n21
Spencer, Herbert, 31, 31n7, 65
Spiders, 44–45, 46–47
Straus, Erwin, 7–8, 22, 83; sen-
sation and, 71–72
Subjectification, 2
Sublimation, 64, 64nn2–3
Swiboda, Marcel, 4n3
Synthetic character, sensations
and, 75n16

Territory, 49n25; architecture,
chaos, cosmos, and, 1–24; mi-
lieu and, 45–51, 47nn22–23;
music's relationship to, 49
Ticks, 41–42; animals and,
42n19, 53
Time, 86, 87; art and forces of
space, nature, and, 3, 9n7
Tjapaltjarri, Clifford Possum; see
Possum, Clifford

Tjapaltjarri, Tim Leura, 97
Tones, 55n32
Turner, J. M. W., 88

Uexküll, Jakob von, 22, 46, 48;
animals, music and, 40–45;
spiders and, 44–45; ticks and,
41–42
Utopia artists communities,
92n41, 93, 93n43, 103

Van de Velde, Henry, 13n11
Van Gogh, Vincent, 73, 78
van Rijn, Rembrandt; see Rem-
brandt
Vibrations: animals, sex, music
and, 25–62; force of, 83;
music, refrain, and, 51–59;
science and, 62; sensations
and, 62n40, 80, 80n25
Visual transmutation, painting
and, 82, 82n28

Warington, R., 67n7
Western desert art, 89, 89n37,
90–91; painting movement
and, 89n38, 92–95, 95n45,
97n46
Wilson, E. O., 31, 65n5
Wöfflin, Heinrich, 18
Worringer, Wilhelm, 15

Zahavi, Amotz, 30n6

PREVIOUSLY PUBLISHED WELLEK LIBRARY LECTURES
IN CRITICAL THEORY

The Breaking of the Vessels
Harold Bloom

In the Tracks of Historical Materialism
Perry Anderson

Forms of Attention
Frank Kermode

Memoires for Paul de Man
Jacques Derrida

The Ethics of Reading
J. Hillis Miller

Peregrinations: Law, Form, Event
Jean-François Lyotard

Reopening of Closure: Organicism Against Itself
Murray Krieger

Musical Elaborations
Edward W. Said

Three Steps on the Ladder of Writing
Hélène Cixous

The Seeds of Time
Fredric Jameson

Refiguring Life: Metaphors of Twentieth-Century Biology
Evelyn Fox Keller

A Fateful Question of Culture
Geoffrey Hartman

The Range of Interpretation
Wolfgang Iser

History's Disquiet: Modernity and Everyday Life
Harry Harootunian

Antigone's Claim: Kinship Between Life and Death
Judith Butler

The Vital Illusion
Jean Baudrillard

Death of a Discipline
Gayatri Chakravorty Spivak

Postcolonial Melancholia
Paul Gilroy